DELAWARE ART MUSEUM
Selected Treasures

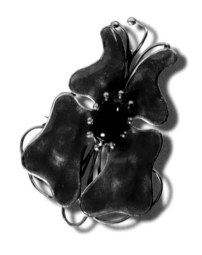

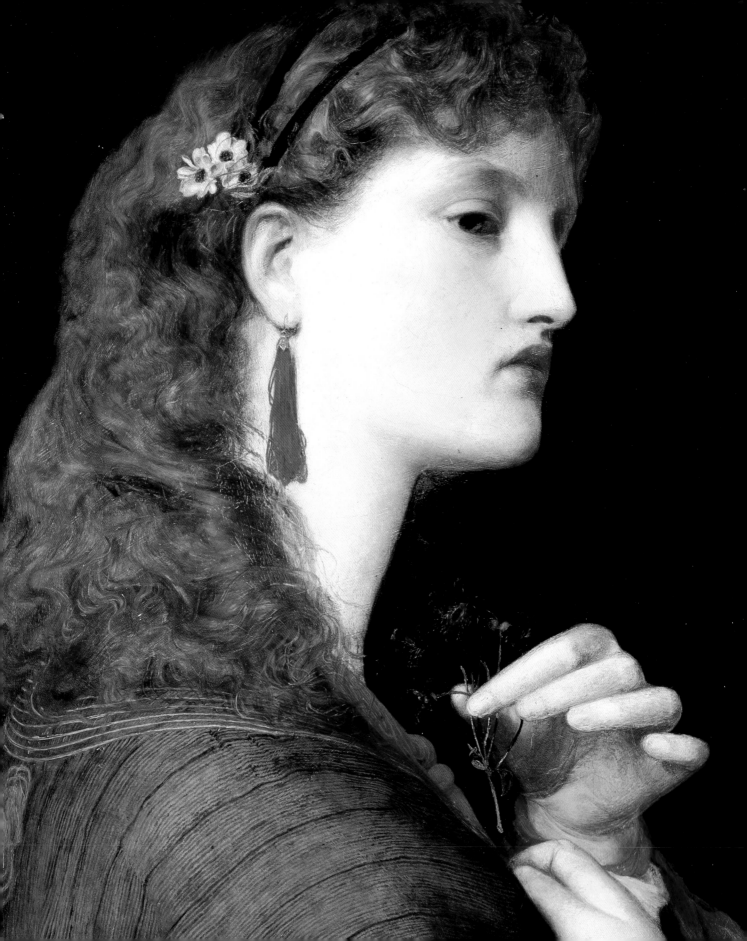

DELAWARE ART MUSEUM
Selected Treasures

SCALA

Copyright © Scala Publishers Ltd
Copyright text and images © Delaware Art Museum

The Delaware Art Museum Council, a volunteer
group dedicated to supporting the Museum's artistic
mission, has generously provided partial funding for
Selected Treasures.

This publication was made possible, in part, by
grants from the National Endowment for the Arts
and the Delaware Division of the Arts, a state agency
committed to promoting and supporting the arts in
Delaware.

Special thanks to the State of Delaware for their
ongoing support of the Museum.

First published in 2004 by
Scala Publishers Ltd
Northburgh House
10 Northburgh Street
London EC1V 0AT

In association with the Delaware Art Museum
2301 Kentmere Parkway
Wilmington, DE 19806
USA

Project Editor: Annabel Cary, Scala Publishers
Editor: Shelby Evans, Delaware Art Museum
Designer: Yvonne Dedman
Produced by Scala Publishers Ltd

ISBN 1 85759 320 0

Printed by CS Graphics, pte, Singapore

Half-title:
Brooch and pendant combined, *c.*1900
C. R. Ashbee
(See page 33)

Frontispiece:
May Margaret (detail), mid-1860s
Frederick Sandys
(See page 20)

Opposite:
Grandfather's Cabin/Noah's Ark (detail), 1993–1996
Elizabeth Talford Scott
(See page 132)

CONTENTS

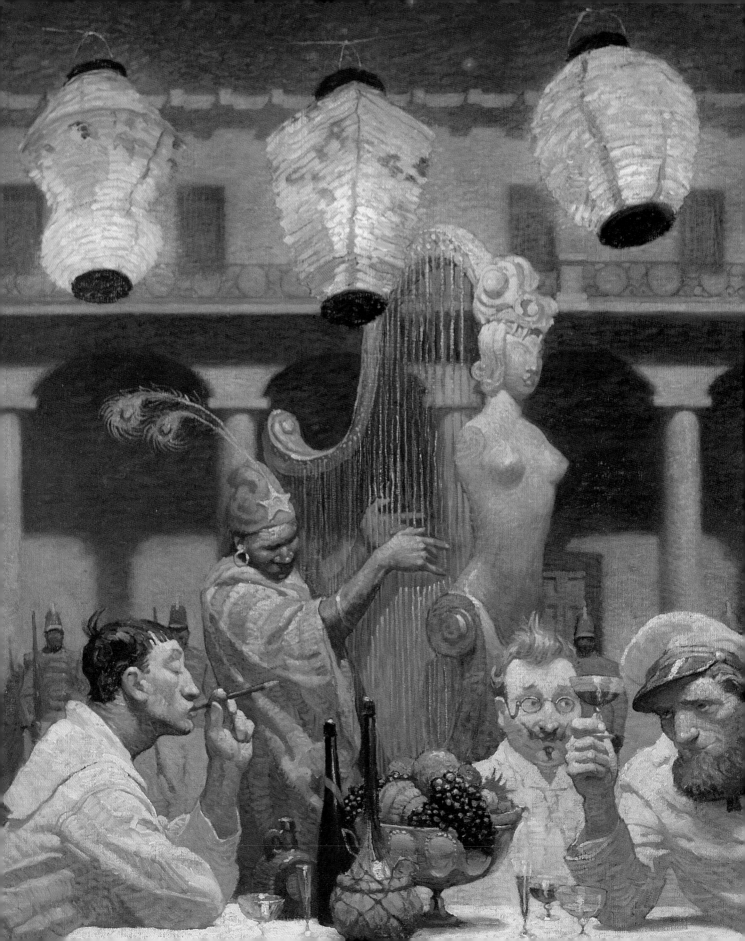

DIRECTOR'S FOREWORD

Delaware Art Museum: Selected Treasures was born of a desire to introduce our visitors to the extraordinary collections of one of America's premier art museums. The publication of this catalog also celebrates the opening of the Delaware Art Museum's expansion and renovation project—a culmination of eight decades of dedication to the fine arts and the communities we serve.

Both the new museum and this sampling of its artistic treasures are a tribute to our founders, philanthropists, collectors, scholars, and an enlightened community of civic leaders. From the Museum's meager beginnings in 1912, led by Mrs. Charles Copeland and the devotees of Howard Pyle, a collection of forty-eight paintings by the major American illustrator has expanded to nearly thirteen thousand works of art. Beyond a survey of more than two hundred years of American art, the Delaware Art Museum boasts collections representing unparalleled depth for several significant movements. In addition to housing more than one thousand paintings and drawings by Howard Pyle and other artists representing the golden age of American illustration, the Museum is recognized as the repository for the largest holdings of the American master John Sloan, whose widow, Helen Farr Sloan, stands as the single most important benefactor to the growth and refinement of our collections during her four decades of philanthropy.

On an international level, the Samuel and Mary R. Bancroft Collection of Pre-Raphaelite art is heralded as the largest and most important collection of this nineteenth-century British art movement on display anywhere outside the United Kingdom. Given to the Museum in 1935, this collection continues to grow and prosper with the worldwide attention it receives.

The successful publication and dissemination of such a beautiful catalog is due to the efforts of an extraordinarily gifted staff and a uniquely supportive Board of Trustees. It is wholly appropriate to recognize Jim Hanley, former Deputy Director, for conceiving of the idea and directing the team that brought this project to fruition. Judith McCabe also deserves special recognition for the role she played in organizing our early efforts. My sincere thanks to other members of the Museum's staff, particularly Kraig A. Binkowski, Judith A. Cizek, Sarena Deglin, Margaretta S. Frederick, Mary F. Holahan, and Joyce K. Schiller, who provided the specialized knowledge of our collections for the essays and critiques you are about to enjoy; to Allison Evans for working so closely and diligently with our publisher and editor to assemble text and images for the book; to Connie Cordeiro for her guidance in marketing; to Lise Monty for the publicity efforts; Carson Zullinger, our photographer, for his care in assuring that each photographic image in this book was the best possible interpretation of the Museum's selected treasures; and finally to Shelby Evans for her excellent editorial work on our behalf.

On a final note, we must express our gratitude to the one person whose thirty-five years of connoisseurship, scholarship, and dedication has provided the foundation for our appreciation of the treasures now entrusted to our care: the late Rowland Elzea, Chief Curator from 1958 to 1993.

Stephen T. Bruni
Executive Director

Opposite:
Illustration for "The Medicine Ship" (detail), 1915
N. C. Wyeth
(See page 65)

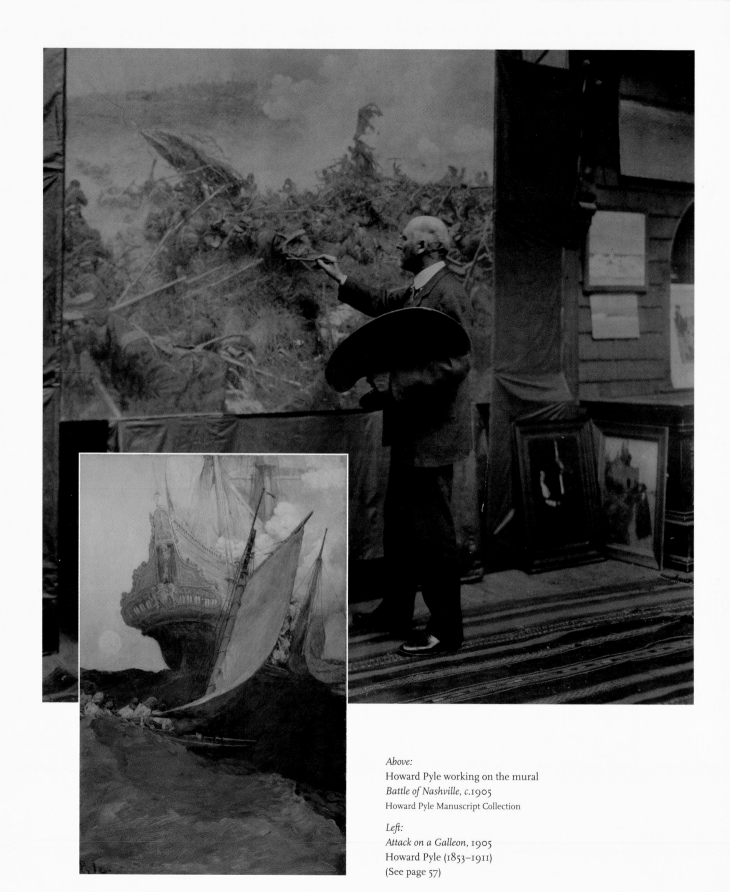

Above:
Howard Pyle working on the mural
*Battle of Nashville, c.*1905
Howard Pyle Manuscript Collection

Left:
Attack on a Galleon, 1905
Howard Pyle (1853–1911)
(See page 57)

DELAWARE ART MUSEUM: A BRIEF HISTORY

Samuel Bancroft, Jr., *c.*1910
Samuel and Mary R. Bancroft Manuscript Collection

A Small Circle of Friends: The Beginning of the Delaware Art Museum
A cold, gray winter evening in early 1912 saw the gathering of a small, diverse group of Delaware residents. Some were artists, others were entrepreneurs and businessmen and women of Wilmington; all were good friends of Howard Pyle.

Howard Pyle, who had played a crucial role in the golden age of American illustration; the man who had put Wilmington on the artistic map with his inspired and impassioned teachings and dedication to his vision of illustration; the man who had made Delaware known for more than its gunpowder, was dead at the age of fifty-eight. Pyle died unexpectedly in November of 1911 while on a trip to Italy with his family. Left behind were a legion of grieving students, friends and admirers.

This gathering of saddened friends decided, on that winter night, that something must be done to honor the memory of the artist and teacher who had touched them all so deeply. This group of Pyle's students and Delaware personalities formed the Wilmington Society of the Fine Arts with the goal of preserving and exhibiting the works of Howard Pyle. Donations from generous local patrons enabled the Society to purchase nearly one hundred of Howard Pyle's works of art—these paintings, drawings, and prints formed the foundation of a collection that would soon include works from some of the most talented illustrators in America.

When the charter of the Society was drawn in 1912, it boasted the signatures of such Delaware luminaries as Louisa du Pont Copeland, and illustrators Stanley M. Arthurs and Frank E. Schoonover. More importantly, it stated a broad vision for the future: "to promote the knowledge and enjoyment of and cultivation in the fine arts in the State of Delaware."

An Extraordinary Gift: A Collection Finds a Home
At the turn of the nineteenth century, Samuel Bancroft, Jr., was a hard-working and successful Wilmington textile manufacturer, yet his burning passion lay far from his mills on the Brandywine River. He was enthralled by the art of the British Pre-Raphaelites, particularly that of artist and poet Dante Gabriel Rossetti. His fascination with the art and lives of these Victorian artists inspired him to assemble the largest and most important collection of British Pre-Raphaelite art and manuscript materials in the United States. In 1935 the family of Samuel Bancroft, Jr., donated his art and manuscript collection to the Wilmington Society of the Fine Arts. The Bancroft family also bestowed eleven acres of gently rolling countryside near Kentmere Parkway, with the provision that a museum be built on the site to house the Pre-Raphaelite collection. As a testament to the dedication and generosity of the officers and members of the Society as well as the residents of Delaware, $350,000 was raised during the worst of the Depression for the museum construction and its endowment.

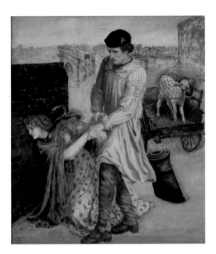

Found, begun 1859
Dante Gabriel Rossetti (1828–1882)
(See page 18)

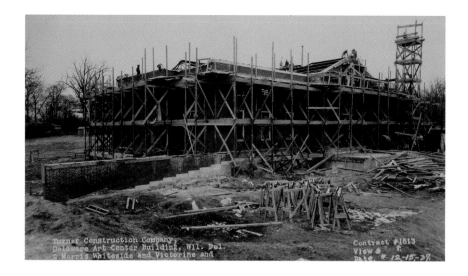

Construction of the original Museum, 1937
Museum Archives

In June of 1938, the newly designated Delaware Art Center opened to the public with galleries devoted to the British Pre-Raphaelites, Howard Pyle and his students, and a growing collection of American art beyond illustration.

The Wilmington Academy of Art joined with the Delaware Art Center in 1943 to establish the Center's first educational programs, and by 1954 nearly five hundred students a year, from across Delaware, were taking part in a wide variety of studio art courses. The overwhelming success of the educational programs stirred the generosity of prominent educational philanthropist H. Fletcher Brown who, in his will, provided for the construction of new studios and classrooms. The H. Fletcher Brown Education wing opened to the public with great fanfare in autumn 1956.

Steadily, the art collection grew along with the changing shape of the museum building. Important works were added to the Pre-Raphaelite and American Illustration collections, and a renewed emphasis on nineteenth- and twentieth-century American artists began to evolve. Major works by Frederic Edwin Church, Winslow Homer, Edward Hopper, Andrew Wyeth, and Paul Cadmus were all added to the collection over the course of a brief period in the 1950s and 1960s.

Helen Farr Sloan and John Sloan
Photographed by Berenice Abbott, c.1950
John Sloan Manuscript Collection

A Singular Friend: Helen Farr Sloan

Helen Farr Sloan, the widow of American artist John Sloan, visited Wilmington for the first time in 1960 to help organize the exhibition, "The Fiftieth Anniversary of the Exhibition of Independent Artists in 1910." The original show had been organized by her husband and included several of his paintings and drawings. Impressed with the collection, the staff, and the Museum's dedication to collecting and exhibiting American art, Mrs. Sloan began to take a keen interest in the Delaware Art Center.

The year 1961 marked the start of a wonderful relationship between Helen Farr Sloan and the Delaware Art Center. Beginning in that year, and throughout the next four decades, Mrs. Sloan has generously donated more than three thousand paintings, prints, and drawings as well as countless manuscript materials, all of which made the

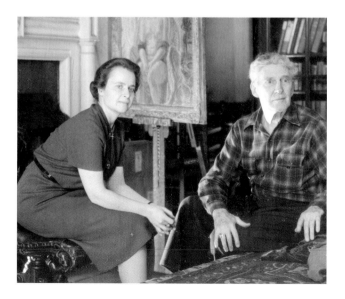

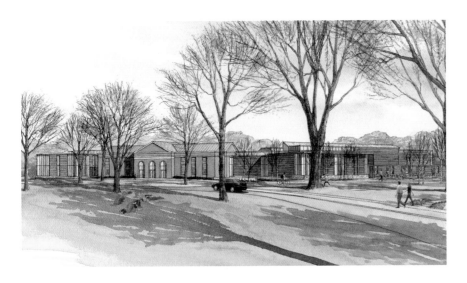

Color rendering of the new
Delaware Art Museum, 2002
Ann Beha Architects

Center a national base for the study of John Sloan and his art. To this day, Mrs. Sloan—a scholar, artist, and patron of the arts—remains a dedicated friend and unwavering supporter of the Museum.

Accreditation by the American Association of Museums in 1972 prompted the Art Center's formal name change to the Delaware Art Museum. Along with this development came the recognition that the Museum and its artworks had evolved into a collection of national and international importance.

With the approach of the twenty-first century came a renewed commitment to enhancing the strengths of the Museum—the British Pre-Raphaelite art, American illustration, John Sloan, and the nineteenth- and early-twentieth-century American art collections all saw major additions in the 1970s, 1980s, and 1990s. In addition, contemporary American artists began to share the spotlight in the increasingly inclusive Museum collection. Works by contemporary masters such as Jacob Lawrence, Louise Nevelson, Robert Motherwell, George Segal, and Jim Dine had been added to the steadily growing collection by the advent of the new millennium.

Of Bricks and Mortar: the Future of the Delaware Art Museum

The Museum has undergone many alterations in its physical appearance—the original structure in 1938, an education wing in 1956, and expanded gallery space and an auditorium in 1987. In 2002 the Museum again undertook a construction project that would greatly transform its visitors' experiences.

Although the outward shell of the Delaware Art Museum has shifted with the attitudes of the times, the heart of the Museum has remained constant. Museums are places of beauty and ideas, places to contemplate and learn. They are places to gather but also to retreat from the pressures of the everyday. People experience museums in immeasurable ways, but at the very heart of every museum is its collection. As the Delaware Art Museum has changed physically, it is important to acknowledge its great fortune in having, at its center, a collection of art that is both beautiful and thought-provoking. It is also imperative to recognize that the Museum has evolved over the decades due to the hard work and generosity of countless dedicated individuals, beginning with that small circle of friends on a cold winter night in 1912.

Kraig A. Binkowski
Head Librarian

Letter to Samuel Bancroft, Jr., from his
cousin Alfred Darbyshire, June 13, 1890

Samuel and Mary R. Bancroft Manuscript Collection

THE HELEN FARR SLOAN LIBRARY

Cover illustration for *Cinder-Path Tales*
Illustrated by John Sloan (1871–1951)
Boston: Copeland and Day, 1896
John Sloan Library

The Helen Farr Sloan Library is the research center of the Museum. Specializing in both American art, from the nineteenth century to the present, and British Pre-Raphaelite art, the Library houses more than thirty thousand volumes that include monographs, exhibition catalogues, periodicals, and reference works.

The history of the Library is intimately intertwined with that of its parent institution. When the Wilmington Society of the Fine Arts opened the new Delaware Art Center on Kentmere Parkway in 1938, two separate libraries, containing the collections of Howard Pyle and Samuel Bancroft, Jr., were established within the galleries of the Society—each located adjacent to its collection's installations. In 1978, after years of contributing art to the Museum, Helen Farr Sloan generously donated the John Sloan Manuscript and Library Collection. To accommodate its extensive materials, the Museum opened a consolidated library in 1985 within the newly constructed Pamela and Lammot du Pont Copeland wing. The Library was named the Helen Farr Sloan Library in honor of Mrs. Sloan's dedication to the Museum and Library collections.

To date, the Special Book Collections include the Samuel Bancroft, Jr., Library of Pre-Raphaelite and Victorian books, the John Sloan Library, and the Howard Pyle Library of illustrated books by Pyle and his students from the golden age of American illustration. The Manuscript and Archives Collections provide unique research opportunities and include more than one thousand boxes of personal papers and materials from John Sloan and Samuel Bancroft, Jr., as well as papers and photographs relating to Howard Pyle and his students.

Sarena Deglin
Archivist, Assistant Librarian

Right:
Howard Pyle and his students at a summer school picnic, Chadds Ford, Pennsylvania, Summer 1899
Cyanotype
Bertha Corson Day Bates Manuscript Collection

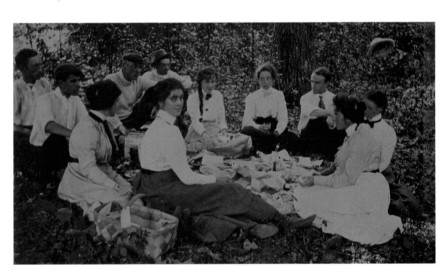

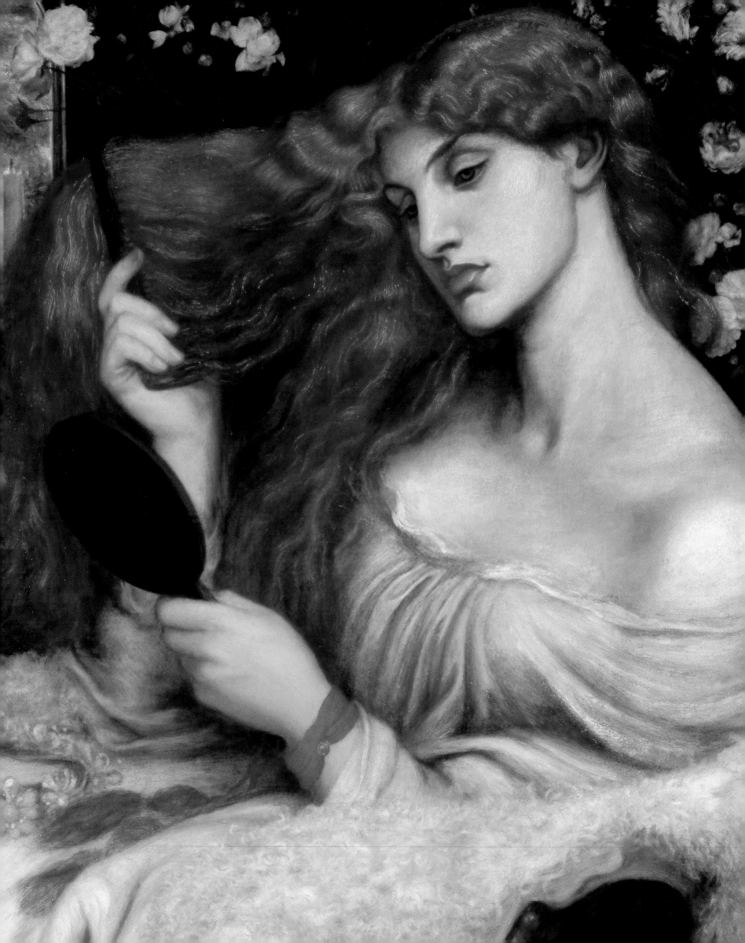

1 *The* SAMUEL & MARY R. BANCROFT PRE-RAPHAELITE COLLECTION

In 1848 a group of seven young British artists and writers gathered together to pioneer a new movement in contemporary art—a move away from the established London art institutions of the day. The group consisted of artists Dante Gabriel Rossetti, William Holman Hunt, John Everett Millais, and James Collins; sculptor Thomas Woolner; and writers William Michael Rossetti (brother of Dante Gabriel) and Frederick George Stephens. Drawing influence from art created before the time of the Renaissance artist Raphael, they intended to paint directly from nature in an honest manner that rejected the painterly brushwork and contrived compositions in vogue at the Royal Academy. Bright, jewel-like color and close attention to detail—modes typical of early Italian art—featured prominently in their work. The founding members of this "Pre-Raphaelite Brotherhood" were very much concerned with the modern world in which they lived, specifically with the social problems brought about by the Industrial Revolution and the rapid urban growth that ensued. Their choice of subjects reflects these concerns and often showed a particular compassion for the "fallen woman," or prostitute.

The young painters gained the support of eminent art critic John Ruskin, who staunchly defended their endeavors in two landmark letters published in the London *Times*. Although the official Brotherhood lasted only a few years, its work and objectives influenced a second generation of English painters and artisans, including Edward Burne-Jones and William Morris, which persisted through the early twentieth century.

In 1880, upon viewing a Pre-Raphaelite painting for the first time, Wilmington textile-mill owner Samuel Bancroft, Jr., described himself as "shocked with delight." Bancroft's decision to collect Pre-Raphaelite art was highly unusual, not only within the local community but throughout the country. Born to a Quaker family with strong British connections, Bancroft was encouraged in his new passion by his English cousin, Alfred Darbyshire, and advised by the Pre-Raphaelite associate and art dealer Charles Fairfax Murray. Bancroft purchased his first Pre-Raphaelite work of art, Dante Gabriel Rossetti's *Water Willow*, in 1890. He continued to add to his holdings, building relationships with living members and descendants of the original Brotherhood, including Jane and Jenny Morris, Winifred Sandys, and Phillip Burne-Jones. As he became more sophisticated in his taste, he sought out archival documents in addition to artwork. Bancroft spent the last thirty-five years of his life acquiring the collection, and by the time of his death in 1915 he had assembled one of the most significant collections of nineteenth-century British art outside of the United Kingdom. Today the collection, bequeathed by Bancroft's family to the Delaware Art Museum in 1935, is one of only a handful in the United States to focus on art of the period.

Margaretta S. Frederick
Associate Curator

Opposite:
Dante Gabriel Rossetti (1828–1882)
Lady Lilith, 1868
Detail from page 21

Sir John Everett Millais (1829–1896)
The Waterfall (also called *Running Water, Landscape Study of a Waterfall, A Study and Background for a Portrait of John Ruskin*), 1853
Oil on paper board
9 5/16 × 13 3/16 in. (23.7 × 33.5 cm)
Samuel and Mary R. Bancroft Memorial, 1935
DAM 1935-53

John Everett Millais painted this diminutive landscape in the summer of 1853 at Glenfinlas, Scotland, where he and his brother William were visiting John Ruskin, the art critic and champion of the Pre-Raphaelite Brotherhood. The group spent sunny days walking, exploring, and sketching. This painting captures the carefree hours the travelers spent together. The figure seated by the mountain stream at the right is Euphemia Chalmers Gray, Ruskin's wife.

Millias's close scrutiny of the natural environment reflects his mentor, Ruskin's artistic ideal of "truth to nature." The particular care taken in the depiction of the rock formations in the foreground is undoubtedly a tribute to Ruskin's keen interest in geology.

The Waterfall also serves as a visual record of the momentous events that were to change the lives of all involved. Within a few years of the completion of this painting, Mrs. Ruskin left her husband and was granted an annulment. In 1855 she and Millais were married, thus bringing an end to the relationship between the two men.

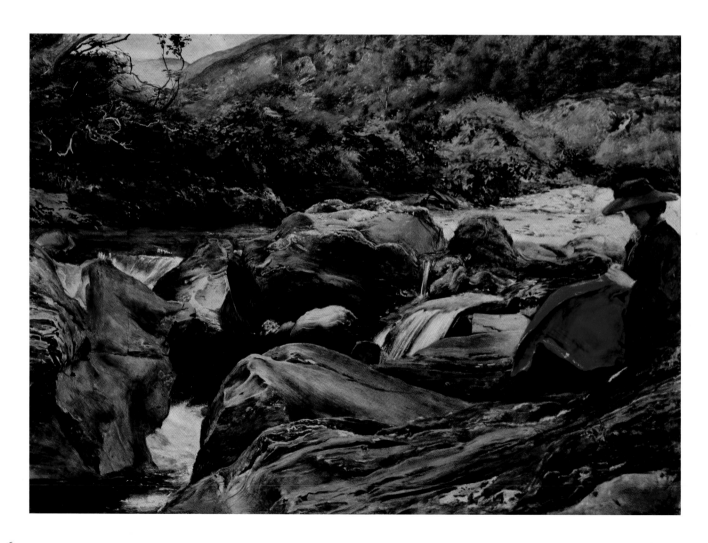

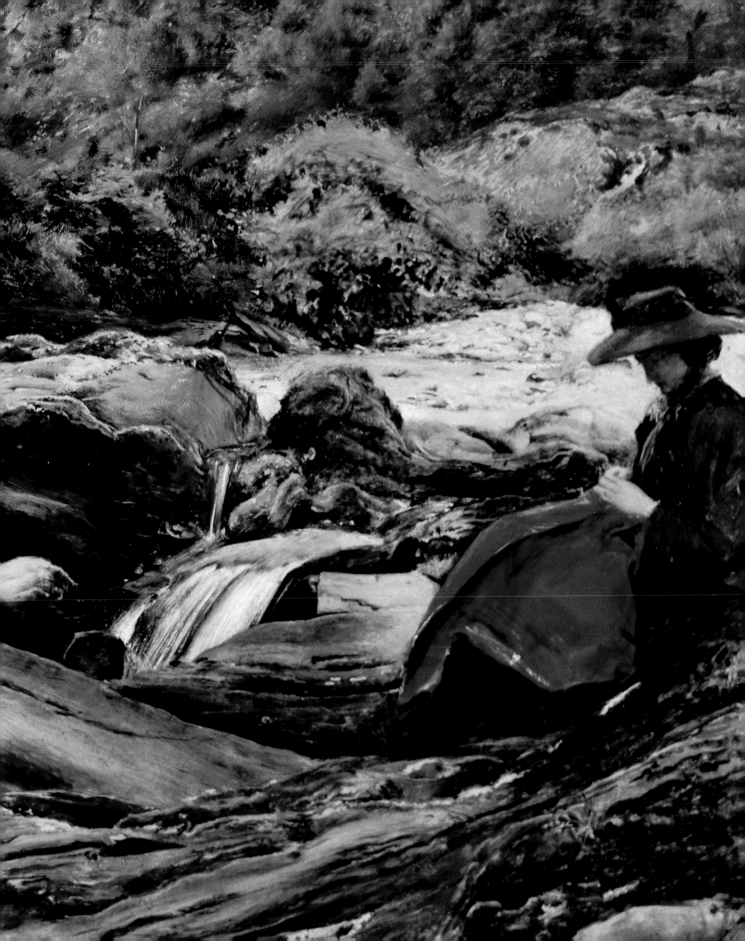

Dante Gabriel Rossetti (1828–1882)
Found, designed 1853; begun 1859
Oil on canvas
36 × 31½ in. (91.4 × 80 cm)
Samuel and Mary R. Bancroft Memorial, 1935
DAM 1935-27

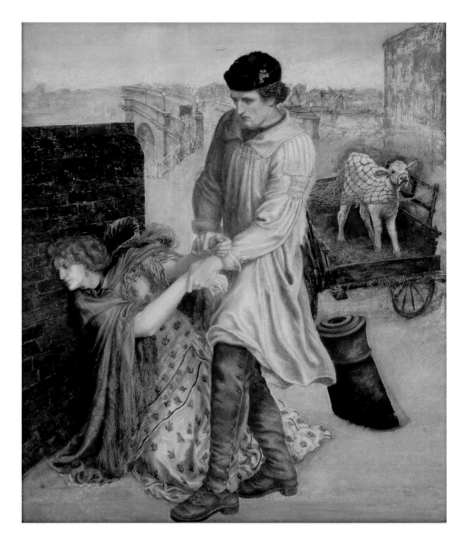

D ante Gabriel Rossetti's *Found* depicts the poignant moment when a young farmer, arriving in London to sell his calf at market, discovers his sweetheart—who has turned to prostitution—homeless and destitute on the streets of the metropolis. This is the only large-scale example of Rossetti's work to grapple with the principles most relevant to the

Pre-Raphaelite Brotherhood in its early years. First, it depicts a scene from contemporary life, rather than the cozy pastoral subjects that were popular at the annual Royal Academy exhibitions. Secondly, it boldly tackles the devastating social issues brought about by the Industrial Revolution and the subsequent urban growth in nineteenth-century Britain. Thirdly, it is executed with painstaking attention to detail— Rossetti spent several months as a guest in fellow artist Ford Madox Brown's rural home in order to properly observe and sketch an actual calf and cart.

Rossetti struggled with this painting for several years before finally putting it aside unfinished, as it remains today. Conceived in 1853, *Found* was still in progress in 1881, a year before Rossetti's death. The fact that this is the only oil painting in which Rossetti was able to fulfill the objectives set forth by the founding Pre-Raphaelites suggests that the young artists who formed the original Brotherhood were a bit naive in their expectations for a "new" art.

William Morris (1834–1898);
Dante Gabriel Rossetti (1828–1882)
The Arming of a Knight, 1856–1857 (left and close-up)
Painted deal, leather, and nails
55⅝ × 18¾ × 19½ in. (141.3 × 47.6 × 49.5 cm)
Acquired through the bequest of Doris Wright Anderson
and the F. V. du Pont Acqusition Fund, 1997

DAM 1997-12

William Morris (1834–1898);
Dante Gabriel Rossetti (1828–1882)
Glorious Gwendolen's Golden Hair, 1856–1857 (right)
Painted deal, leather, and nails
55⅝ × 17 × 17 in. (141.3 × 43.2 × 43.2 cm)
Acquired through the bequest of Doris Wright Anderson
and the F. V. du Pont Acqusition Fund, 1997

DAM 1997-13

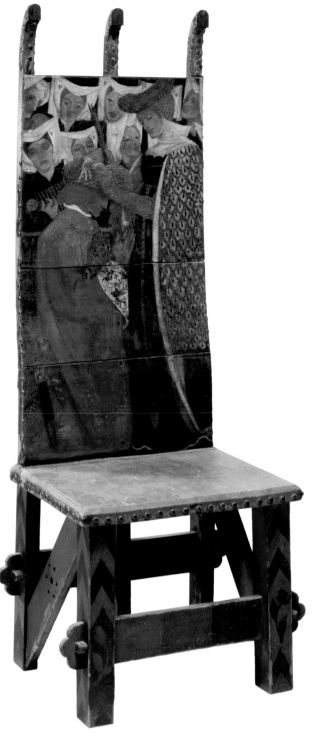

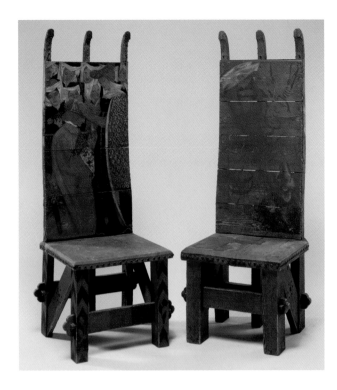

The interest in medieval subject matter, manifest in the work of members of the original Brotherhood, was carried on by the second generation of Pre-Raphaelites. For many artists of the time, a desire for historical accuracy led to intensive investigations into all aspects of the historical period to be depicted. For the Pre-Raphaelites, however, authenticity was less important than the creation of an overall aura of an earlier age. In 1856 William Morris and Edward Burne-Jones took rooms together at London's Red Lion Square. Morris and Dante Gabriel Rossetti collaborated on the design of these chairs in an attempt to create an interior for the rooms that evoked the spirit of the Middle Ages. The sturdy design of the chairs reflects both an understanding of medieval art and architecture, and a desire on the part of the young artists to create functional handmade home furnishings.

The subject of the paintings on the backs of the chairs is drawn from Morris's poetry. The reverse of the chairs is decorated with a chevron pattern, a motif typical of the Middle Ages.

Frederick Sandys (1829–1904)
May Margaret, mid-1860s
Oil on canvas
17½ × 11½ in. (44.5 × 29.2 cm)
Samuel and Mary R. Bancroft Memorial, 1935
DAM 1935-32

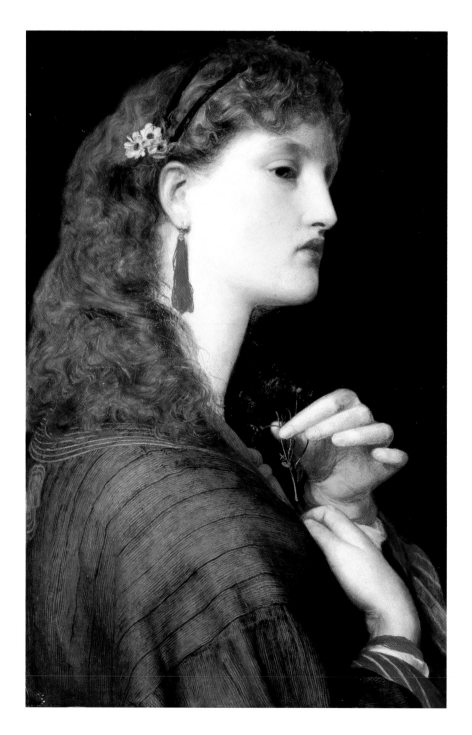

Frederick Sandys, the son of a professional painter, was born in Norwich, England. In 1851 he moved to London where he worked as an illustrator. A superlative draftsman, Sandys produced a significant body of engraved work during this period, before he began painting in earnest in the late 1850s and 1860s. His oil paintings suggest an avid interest in Flemish art of the fifteenth century. *May Margaret* is typical of Sandys's mature work—precise and thinly painted, with pristine, smooth, almost glossy surfaces.

May Margaret is a bust-length portrait of a young woman with long, reddish blond hair. She wears a handwoven and embroidered African robe, which also appears in at least two paintings by Dante Gabriel Rossetti. Sandys lived with Rossetti for two years in the 1860s and may have painted this subject during that time, borrowing his friend's costume as a prop.

The subject of the painting is not known for certain. *May Margaret* may refer to a character of the same name in the traditional Scottish ballad "Clerk Saunders," a version of which was published by Sandys' friend William Allingham in 1865. But the figure in this painting bears little resemblance to that story's maiden, who is haunted by her dead lover.

See detail on frontispiece

Dante Gabriel Rossetti (1828–1882)
Lady Lilith, 1868
Oil on canvas
38½ × 33½ in. (97.8 × 85.1 cm)
Samuel and Mary R. Bancroft Memorial, 1935
DAM 1935-29

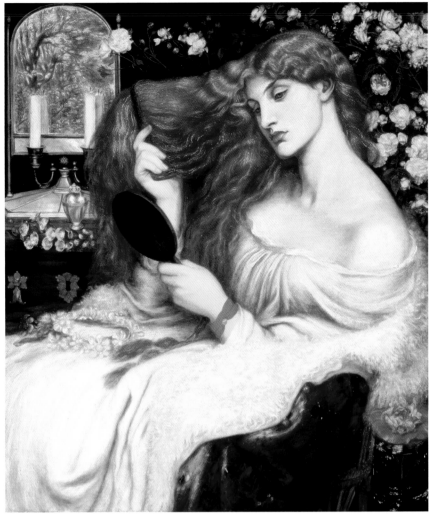

See detail on page 14

L ilith, whose character originates in Assyrian mythology, recurs in Judaic literature as the first wife of Adam. She is associated with the seduction of men and the murder of children. The depiction of women as powerful and evil temptresses was prevalent in nineteenth-century painting, particularly in that of the Pre-Raphaelites.

Rossetti wrote a poem, which is inscribed on the frame, to accompany this work:

> *Of Adam's first wife, Lilith, it is told*
> *(The witch he loved before the gift of Eve),*
> *That, ere the snake's, n'er sweet tongue could deceive,*
> *And her enchanted hair was the first gold.*
> *And still she sits, young while the earth is old,*
> *And subtly of herself contemplative,*
> *Draws men to watch the bright net she can weave.*
> *Till heart and body and life are in its hold.*

Rossetti depicts Lilith as an iconic, Amazon-like woman with long, flowing hair. She idles listlessly in a richly decorated interior, dreamily admiring her reflection in a mirror. Her languid demeanor is reiterated by the poppy—the flower associated with opium-induced slumber—in the lower right corner of the painting.

Though Rossetti originally based the woman's image on his mistress, Fanny Cornforth, he later repainted it with the more classical features of Alexa Wilding, one of his favored models at the time. Rosetti's watercolor replica of this painting, in the collection of the Metropolitan Museum of Art in New York, retains the more sensual features of the original model.

William Holman Hunt (1827–1910)
Isabella and the Pot of Basil,
1867–1868
Oil on canvas
23⅞ × 15¼ in. (60.7 × 38.7 cm)
Special Purchase Fund, 1947
DAM 1947-9

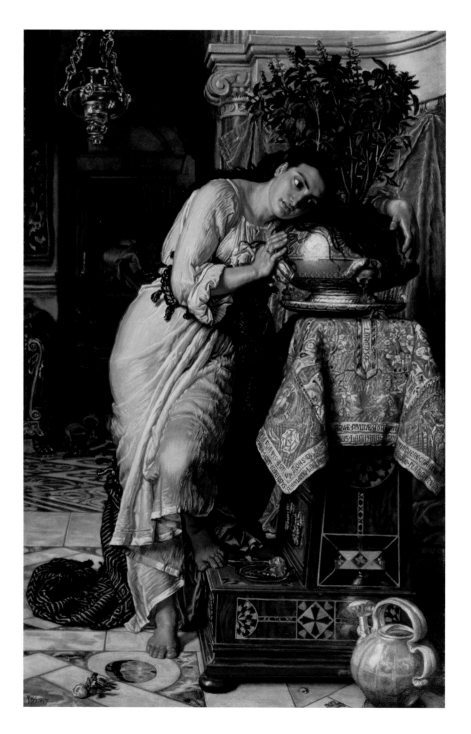

The subject of *Isabella and the Pot of Basil* refers to a poem of the same title by John Keats. The Pre-Raphaelite artists greatly admired Keats's romanticism, and the themes of many of their paintings were drawn from his work.

Keats's poem, in turn, was inspired by an earlier work of the Italian Renaissance poet Giovanni Boccaccio, which features the young lovers Lorenzo and Isabella. In the gruesome tale, Isabella's brothers murder Lorenzo because they wish her to marry someone else. When Isabella discovers Lorenzo's body, she cuts off his head and buries it in a pot of basil, watering it with her tears.

The painting is filled with exotic objects, including a prie-dieu, which Hunt purchased in Florence, and a bronze pot. Hunt had traveled to the Holy Land in 1854, and this work, with its rich fabrics and flooring, reflects his enthusiasm for Middle Eastern culture.

Hunt began this painting in Florence, in 1867, shortly after the death of his first wife, Fanny Waugh, and he created it from two earlier portraits of her. Hunt's choice of subject is undoubtedly autobiographical, reflecting his sadness and mourning for his wife.

A larger version of the painting—Hunt frequently painted more than one version of a subject—was exhibited in 1868, and is in the collection of the Laing Art Gallery in Newcastle, England. In the nineteenth century, unlike today, replicas and copies were considered equally as valuable as the original.

Dante Gabriel Rossetti (1828–1882)
Water Willow, 1871
Oil on canvas on wood
13 × 10 in. (33 × 26.6 cm)
Samuel and Mary R. Bancroft Memorial, 1935
DAM 1935-26

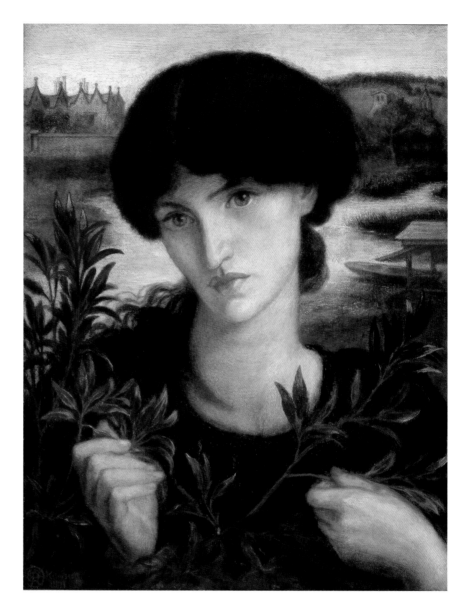

Water Willow is a portrait of Jane Morris, the wife of William Morris, Rossetti's friend and collaborator. In 1871 Morris and Rossetti signed a joint lease on a house, Kelmscott Manor, in Oxfordshire. Morris then departed for an extended trip to Iceland, leaving his wife and Rossetti to spend the summer together at the house. During that time, Rossetti and Jane Morris formed a close attachment that is revealed in numerous paintings for which she modeled, as well as in his passionate poetry of the period.

The painting is virtually without a story, which is unusual among those that feature Jane Morris. More often she is depicted in scenes of ill-fated lovers. Nonetheless, in *Water Willow* Rossetti conveys a feeling of sadness by including the willow branch, a symbol of sorrow. Kelmscott Manor appears in the background, making this painting a kind of commemorative of the time the two spent together.

This painting is of particular significance to the Delaware Art Museum, as it was the first Pre-Raphaelite work acquired by Samuel Bancroft, Jr.—the spark that ignited a passion reflected in the richness and depth of the present-day collection. When presented with the opportunity to buy *Water Willow* in 1890, Bancroft exclaimed in a letter to his cousin, "I have an idea that I shall be the owner of a unique example if I get this one."

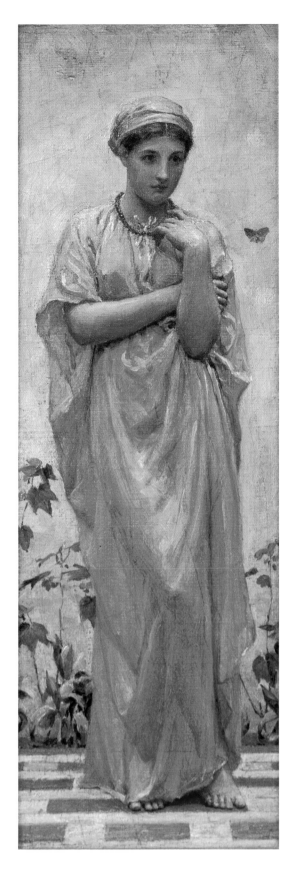

Albert John Moore (1841–1893)
A Study in Yellow (also called *The Green Butterfly*), c.1878–1881
Oil on panel
15 7/16 × 5 1/4 in. (39.2 × 13.2 cm)
Samuel and Mary R. Bancroft Memorial, 1935
DAM 1935-16

Albert Moore was born in York, England, to a family of painters. He studied briefly at the Royal Academy in London before visiting Rome in the early 1860s, a journey that kindled his lifelong interest in classical sculpture. By the mid-1860s he began painting the images of classically draped women for which he is best known.

This work is an example of an aesthetic trend in late nineteenth-century British art—a movement led by Moore's close friend James McNeill Whistler—that focused on form and color harmonies, rather than subject matter. The apparent simplicity of *A Study in Yellow*'s composition is deceptive: Moore worked meticulously, making extensive figural studies and oil sketches, in which he experimented with color, the fall of the drapery, and choice of decorative textiles, before arriving at the finished painting.

Samuel Bancroft, Jr., purchased this painting, along with Burne-Jones's *Head of Nimue* and Alfred Fahey's *Within the Beguinage*, from Thomas Agnew & Sons in March of 1906.

Sir Edward Burne-Jones (1833–1898)
The Council Chamber, 1872–1892
Oil on canvas
49 × 104 in. (124.4 × 264.1 cm)
Samuel and Mary R. Bancroft Memorial, 1935
DAM 1935-3

The subject of this painting refers to a scene originally described in "Little Briar-Rose," a Grimm Brothers fairy tale more commonly known as "Sleeping Beauty." The tale inspired the Alfred Lord Tennyson poem "The Day-Dream," which was probably Edward Burne-Jones's inspiration for this work.

The subject is one to which Burne-Jones returned periodically throughout his life. He first embraced the theme in an 1864 tile panel he designed for the home of fellow artist Myles Birket Foster. He turned to the story again in 1869 to create a set of three oil paintings, now in the collection of the Museo de Arte de Ponce in Puerto Rico. In 1889 Burne-Jones completed a series of four larger panels and exhibited them in London to great acclaim. The works, depicting "The Briar Wood," "The Council Chamber," "The Rose Bower," and "The Garden Court," were purchased by financier Alexander Henderson and installed in his home, Buscot Park, outside of London.

In 1885 Burne-Jones began three additional paintings for yet another series of the same subject. The Delaware Art Museum's *Council Chamber* was part of this project. The scene, in which the king and his court are shown in a deep sleep, awaiting the arrival of the prince to awaken them, is echoed in the lines William Morris wrote to accompany the painting:

> *The threat of war, the hope of peace,*
> *The Kingdom's peril and increase*
> *Sleep on and bide the latter day,*
> *When fate shall take her chains away.*

◄ *Fold out*

Sir Edward Burne-Jones
The Council Chamber

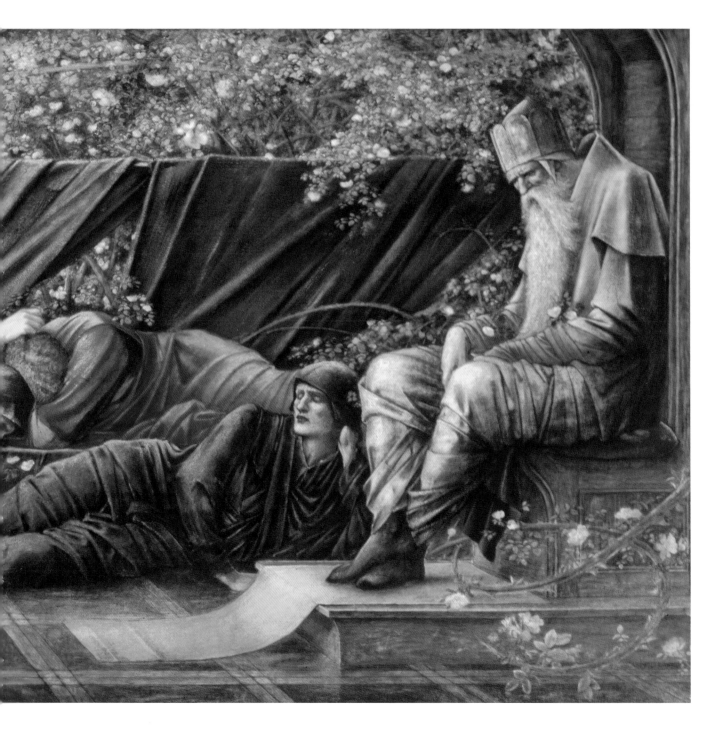

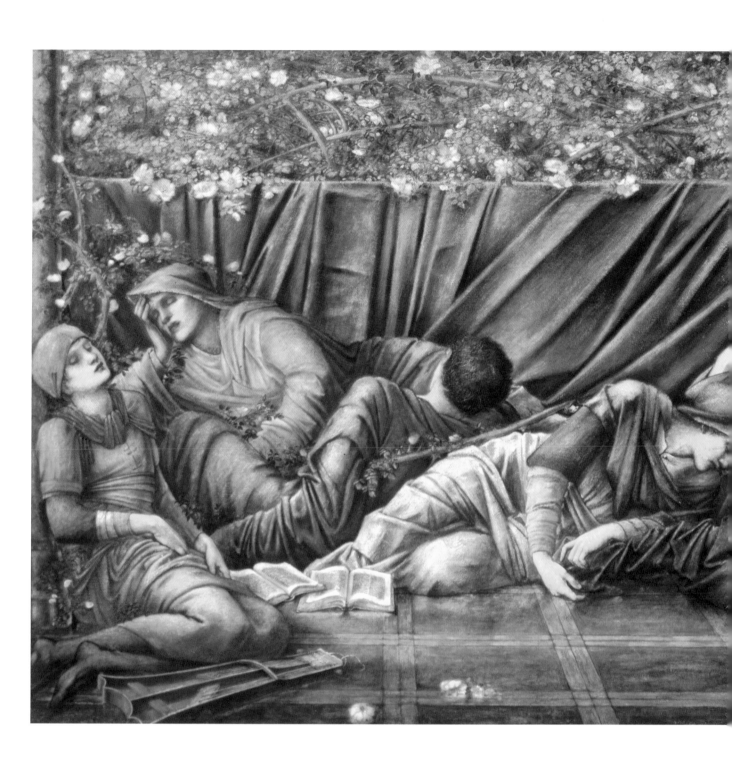

Dante Gabriel Rossetti (1828–1882)
La Bella Mano, 1874–1875
Oil on canvas
62 × 46 in. (157.5 × 116.8 cm)
Samuel and Mary R. Bancroft Memorial, 1935
DAM 1935-25

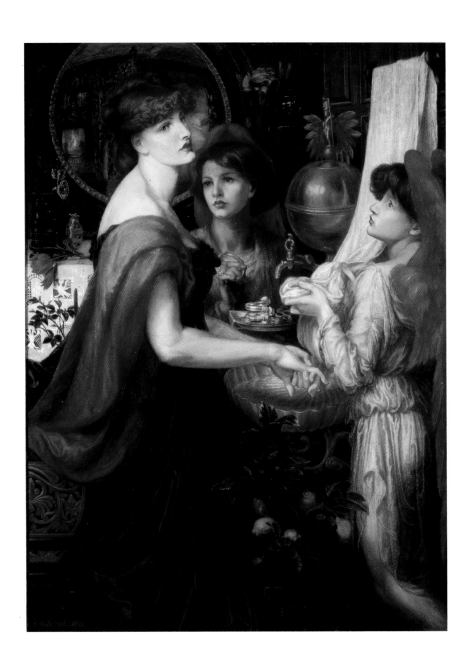

This painting—which Rossetti completed relatively quickly, as it was a commission from his publisher, Frederick Ellis—exemplifies the artist's mature style. It deviates significantly from the simplicity and truth-to-nature imperatives of the early Brotherhood. The year that *La Bella Mano* was completed, Rossetti wrote a sonnet of the same title, meaning "beautiful hands," which is inscribed on the frame in Italian. Throughout his life Rossetti was interested in merging written text with visual image to convey his personal vision in the fullest sense. Poem and painting, taken together, reflect and enhance one another in a manner that is an exemplar of what modern-day art historians have termed the "double work of art."

Samuel Bancroft's acquisition of *La Bella Mano* in 1909 was the ultimate purchase of his collecting career. In the summer of that year, Bancroft's agent in London had informed him of the sale of an important private collection of Pre-Raphaelite art. In a flurry of transatlantic telegrams, the bid was placed and the news of success relayed. Upon learning of his new purchase, Bancroft cabled his agent jubilantly, "Thanking you for your care in the matter, and trusting that I have got the best Rossetti in existence...!"

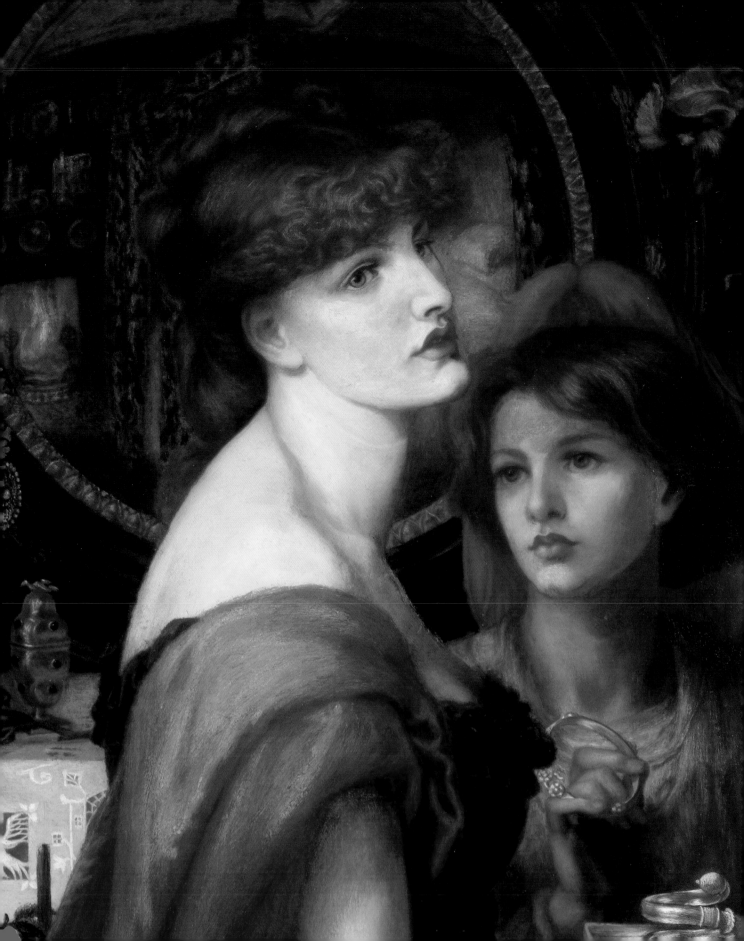

Marie Spartali Stillman (1844–1927)
Love's Messenger, c.1885
Watercolor, tempera, gold paint on paper
mounted on wood
32⅝ × 26⅜ in. (82.9 × 67 cm)
Samuel and Mary R. Bancroft Memorial, 1935
DAM 1935-75

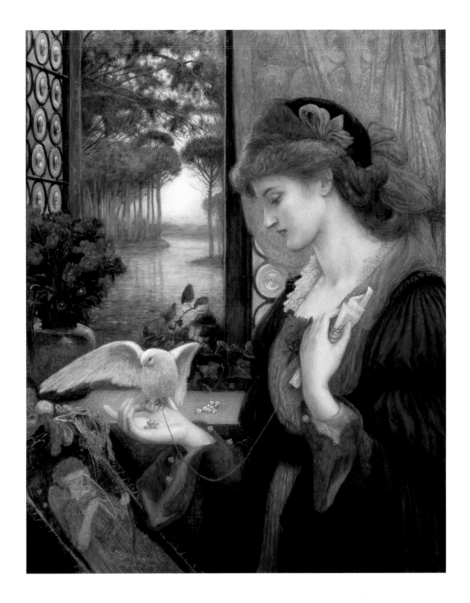

Marie Spartali was born into the wealthy Greek community of Victorian London. She was taught by Pre-Raphaelite mentor Ford Madox Brown and also modeled for Dante Gabriel Rossetti. In 1871 she married the American journalist William J. Stillman; thereafter the couple divided their time between England and Italy. *Love's Messenger*, an example of Stillman's mature work, shows the combined influence of Burne-Jones and Italian Renaissance artists such as Sandro Botticelli.

Like many female artists of the period, Stillman worked primarily in watercolor or gouache. Watercolor was the medium considered most suitable for women artists who, during the Victorian period, were regarded as artistically inferior to men.

In this painting a dove, bearing a love letter, lands on the hand of a woman who stands before an open window. She rewards the dove for its efforts with kernels of corn. In front of her lies the embroidery she has set aside, which depicts a blindfolded cupid.

Samuel Bancroft, Jr., saw *Love's Messenger* when visiting London in 1901 and inquired after its artist. In response, Stillman wrote delightedly, "I feel much flattered that you liked my picture 'Love's Messenger'....The price is 100£." Following the painting's dispatch in May of that year, Bancroft wrote excitedly to a friend, "Today I learn that the Steamer 'Eagle Point' is in the Delaware on her way up to Philadelphia; and I suppose the picture will be here in a few days...."

Robert Wallace Martin (1843–1923),
sculptor
R. W. Martin & Brothers Pottery
Bird Jar, 1889
Stoneware
Height: 10½ in. (26.7 cm)
F.V. duPont Acquisition Fund, 2001
DAM 2001-5 a, b

Robert Wallace Martin (1843–1923),
sculptor
R. W. Martin & Brothers Pottery
Bird Jar, 1901
Stoneware
Height: 11⅞ in. (30.2 cm)
F.V. duPont Acquisition Fund, 2001
DAM 2001-7 a, b

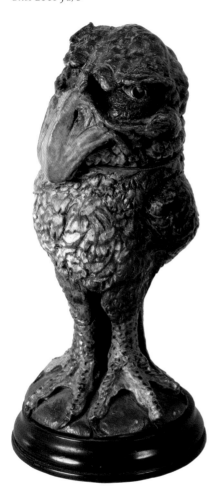

produced—stained glass, tapestries, embroidery, pottery, glassware, and furniture—exhibit a common penchant for honest craftsmanship and simple ornamentation.

Four English studio potter brothers, Robert Wallace, Charles, Walter, and Edwin Martin, first began producing salt-glazed stoneware in 1873, working out of their home, Pomona House, in Fulham. In 1877 they moved to larger, permanent premises in Southall, Middlesex. The pottery produced was quite varied in design. Robert Wallace was the creator of the odd creatures, of which these two bird jars are examples, that are most commonly associated with the Martin Brothers.

The quirky, fantastic nature of these Martin Brothers creatures reflects an aspect of Victorian character similarly apparent in the writings of Lewis Carroll, the caricatures of Edwin Lear, and the fairy illustrations of Arthur Rackham. Such forays into the imaginary and surreal are often explained as a Victorian desire to escape the ugly realities of the Industrial Age.

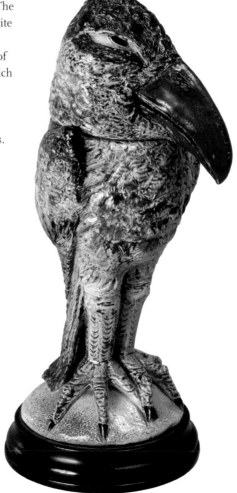

The Arts and Crafts movement, which began and flourished in Britain during the latter half of the nineteenth century, was first and foremost a response to the Industrial Age. Encouraged by the writings of John Ruskin, who condemned machine-made household objects, the movement was inspired and sustained to a large extent by the work of William Morris. Although there was no universally binding manifesto, the works

C. R. [Charles Robert] Ashbee
(1863–1942), designer
Guild of Handicraft Ltd.
*Brooch and Pendant Combined
(Flower form)*, c.1900
Enamel on silver with cabochon amethyst
2 × 1½ × ⅝ in. (5.1 × 3.8 × 1.6 cm)
Gift of Mrs. H. W. Janson, 1976
DAM 1976-36

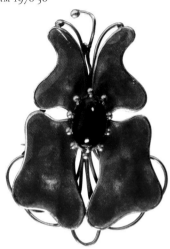

Archibald Knox (1864–1933)
Biscuit Box, c.1903
Pewter with stamped and chased
decoration and enameling
4⅞ × 4½ × 4½ in. (12.4 × 11.4 × 11.4 cm)
Gift of Mrs. H. W. Janson, 1976
DAM 1976-41

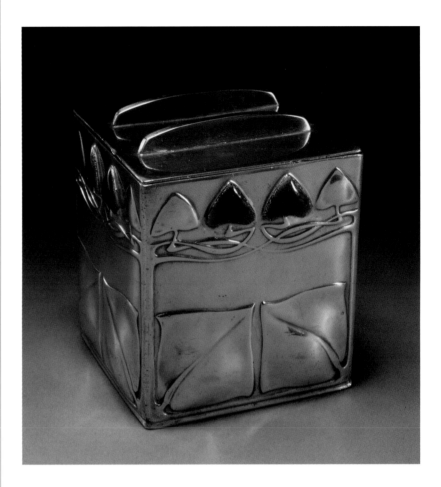

C. R. Ashbee, a designer, writer, and architect, was strongly influenced by the writings of John Ruskin and William Morris. He was particularly enamored of the type of handcraftsmanship practiced in the Middle Ages. In 1888 he set up the Guild of Handicraft, an organization of designers and craftsmen that operated in the manner of a cooperative. At first limited to furniture and metalwork, the Guild added jewelry and silverwork to its repertoire in 1891.

Ashbee was responsible for almost all of the design work for the Guild. His mature work, which made use of simple materials such as inexpensive stones and silver wire, represents some of the first true examples of Arts and Crafts jewelry.

This piece, which could be worn either as a brooch or pendant, typifies Ashbee's use of natural forms in his designs—a flower, butterfly, or bat may have provided inspiration.

The decorative works created by Archibald Knox exemplify a turn-of-the-century transition from the earlier, English Arts and Crafts movement to that of Continental Art Nouveau. Born on the Isle of Man, west of Britain in the Irish Sea, Knox went to London in 1897. Shortly thereafter, he began designing for the household goods emporium Liberty and Company, where he worked from 1904 to 1912. The patterns he drew for the company combined the Celtic forms of his native region with his own modern sensibility.

In 1913 Knox left Liberty and Company to start his own firm, the Knox Guild of Craft and Design. During his lifetime Knox designed a broad range of products for the home, including metalwork, jewelry, textiles, ceramics, and stoneware. The biscuit box was a popular product, and Knox produced them, in various designs, in great numbers. The tulip-like designs on the sides of the box and the organic tracery are clearly of an Art Nouveau sensibility.

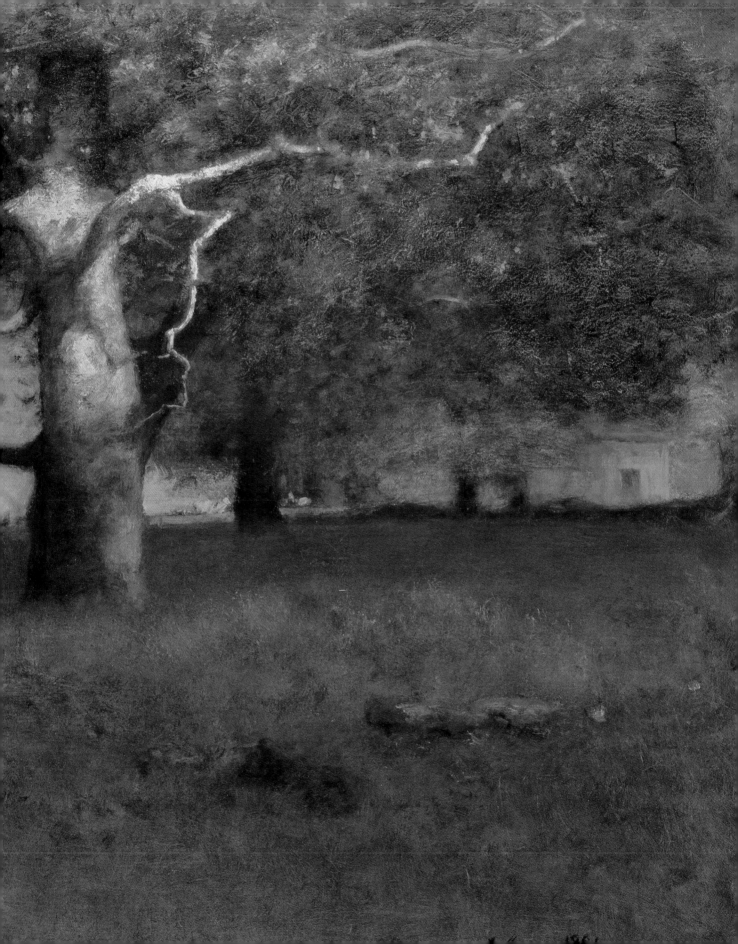

2

AMERICAN ART OF THE NINETEENTH CENTURY

The Delaware Art Museum's Nineteenth Century collection includes works that represent the wide range of styles and influences that affected American art throughout the period. From the time of the colonial settlers, in the late eighteenth century, through the 1820s, portraits were the premier art form in America. Created as a record of personal likeness, importance, and affluence, early portraiture reveals an American determination to succeed. Raphaelle Peale's 1810 portrait of Absalom Jones, for example, captures the clergyman's serious demeanor and documents his importance in the community.

In the 1820s still-life paintings gained popularity among Americans, who began to demand objects of culture to adorn their homes. These paintings, which reflected the abundance available in America, remained fashionable through the end of the nineteenth century. Still-life subject matter was interpreted in a range of styles, from simple arrangements such as John F. Francis's small painting of fruit, to Severin Roesin's sumptuous, mid-century painting of fruit and a bird's nest, to the eye-catching 1888 *Old Violin* by Jefferson David Chalfant.

During the same period, landscape became the foremost subject of American painting, which celebrated a sense of the glory and beauty of the environment. These paintings depicted the land as vast, fertile, and apparently unsullied by thousands of years of civilization. Though most of the scenes were domestic, American taste in landscapes extended to the exotic, as seen in the 1873 *South American Landscape* by Frederic Edwin Church. Later in the century, landscape painters often incorporated a spiritual aspect, as seen in George Inness's 1891 *Early Autumn, Montclair*, or adopted Impressionistic techniques, as in John Henry Twachtman's relentless *Sea Scene* from 1893.

After the Civil War, American art subjects and styles broadened under a variety of influences. Some artists focused on the everyday life of Americans such as the farm workers depicted in Winslow Homer's 1875 *Milking Time*. Other American artists studied abroad, returning with a style prevalent elsewhere—as in Thomas Wilmer Dewing's *Morning* of 1879. Still others returned to the United States, dedicated to a new style of realistic-yet-expressive portraiture, as seen in Augustus Saint-Gaudens's mid-1880s sculpture *Head of Abraham Lincoln*.

Joyce K. Schiller
Curator

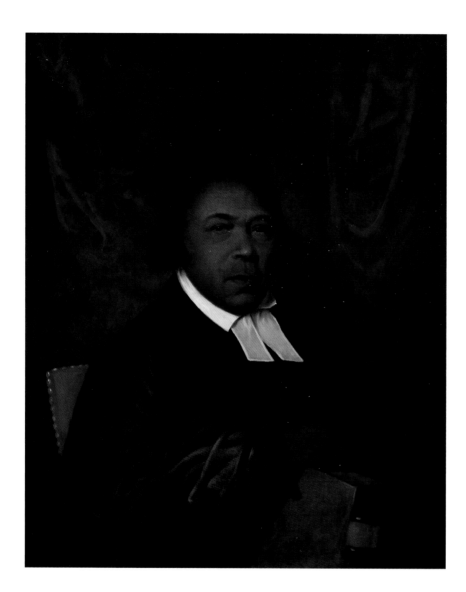

Raphaelle Peale (1774–1825)
Absalom Jones, 1810
Oil on paper mounted to board
30 × 25 in. (76.2 × 63.5 cm)
Gift of Absalom Jones School, 1971
DAM 1971-8

Raphaelle Peale was the eldest son of American painter Charles Willson Peale and one of the many artists in the Peale family. He was trained by his father and by his uncle, painter James Peale. While Raphaelle Peale is perhaps best known for his still-life paintings, his portraits are also highly regarded. Charles Willson Peale called his son's portrait of the Reverend Absalom Jones "a very excellent picture."

The subject, Absalom Jones, was born a slave in Sussex, Delaware, in 1746, and eventually won his freedom, after which he worked in Philadelphia as a store clerk. In 1789 Jones was serving St. George's Methodist Church in Philadelphia as a Sunday school teacher when the church decided to segregate its black membership from the rest of the congregation. Appalled by their decision, Jones left the church and petitioned the Bishop of Pennsylvania to designate a new parish for the African Americans of the community. Jones served the new house of worship, St. Thomas African Episcopal Church, first as a lay reader and then, after his ordination, as the church's rector. Jones was ordained as deacon in 1795 and as priest in 1802. Jones helped to organize the Free African Society to aid and support Negroes in 1792 and to create a school for black children in 1818.

Peale's portrait of Absalom Jones reveals a determined gentleman in a cleric's collar. Jones's face is sternly set, and his right hand holds a large volume, probably a bible.

Thomas Sully (1783–1872)
Rebecca Gratz, 1830
Oil on canvas mounted on Masonite
20 × 17 in. (50.8 × 43.2 cm)
Gift of Mr. Benjamin Shaw II, 1971
DAM 1971-167

English-born Thomas Sully was reared in Charleston, South Carolina. His primary artistic training came from members of his family and, later, from artist Benjamin West in London. Eventually, in 1810, Sully settled in Philadelphia, where he became the leading portrait painter of that city.

The painting's subject, Rebecca Gratz, had assisted Sully's introduction into Philadelphia society at the request of mutual acquaintance Washington Irving. Sully painted seven portraits of various Gratz family members, including three known paintings of Rebecca. Although Rebecca Gratz never married, her familial devotion extended to the raising of six nieces and nephews after her sister's death. Gratz was also an influential participant in various charitable organizations in Philadelphia, including the founding of the Female Hebrew Benevolent Society in 1819 and the Hebrew Sunday School Society in 1838.

This portrait, with its unconventional head covering and pose, chosen by Gratz, was commissioned by one of her brothers, Hyman Gratz. Sully's mature portraits, such as *Rebecca Gratz*, are known for the fluency of brush and stylish compositions. This painting is an excellent example of Sully's sensitive and rather romantic portraiture.

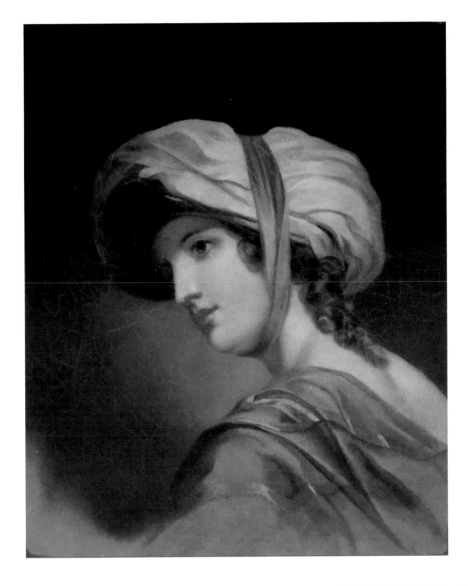

Severin Roesen (*c.*1816–1872)
Still Life with Fruit, *c.*1865
Oil on canvas
33¾ × 43¾ in. (85.7 × 111.1 cm)
Acquired through the bequest of Miss Ellen Buckelew, 1970
DAM 1970-13

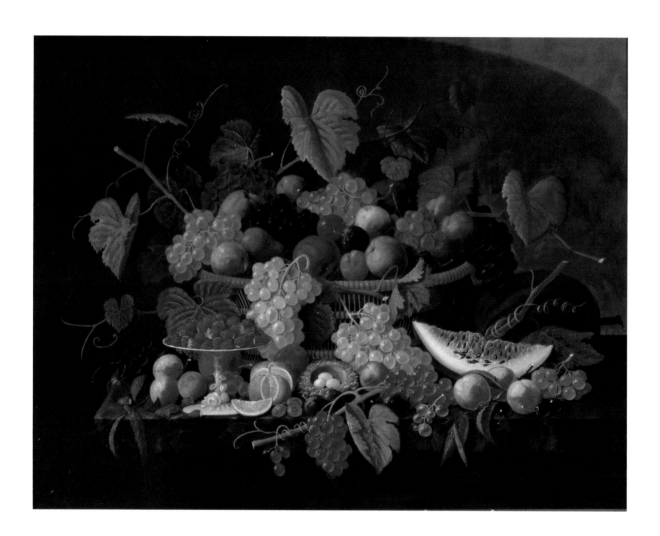

Little is known of Roesen's personal life and training. He was born in Germany near Cologne and is thought to have trained as a porcelain and enamel painter. In 1847 he immigrated to the United States, where he became known for his floral and fruit compositions; he was soon exhibiting still-life paintings in New York City. In the late 1850s Roesen settled in the Pennsylvania town of Williamsport.

Roesen's sumptuous still-life paintings reflect a sense of abundance and comfortable opulence. In *Still Life with Fruit*, a profusion of fruits overflows its basket and the table's edge.

Roesen's paintings clearly reflect an ancestry in seventeenth-century Dutch still life, in which each object in an arrangement was rendered distinctly. Such paintings were as much about the transience of life as they were about the food they portrayed. Roesen's fruits, which ripen in different seasons, are each shown at their moment of perfect maturity and serve as a celebration of beautiful prosperity, conveyed in a crisp, clear style. Roesen's repetition of similar motifs within his body of work indicates that he may have used templates of the various subjects to create new arrangements.

Jefferson David Chalfant
(1856–1931)
The Old Violin (also called *Violin,
Violin and Music, Still Life with
Violin*, and *The Violin and Music
on a Door*), 1888
Oil on canvas on board
40 × 28¼ in. (101.6 × 71.8 cm)
Louisa du Pont Copeland Memorial
Fund, 1940
DAM 1940-6

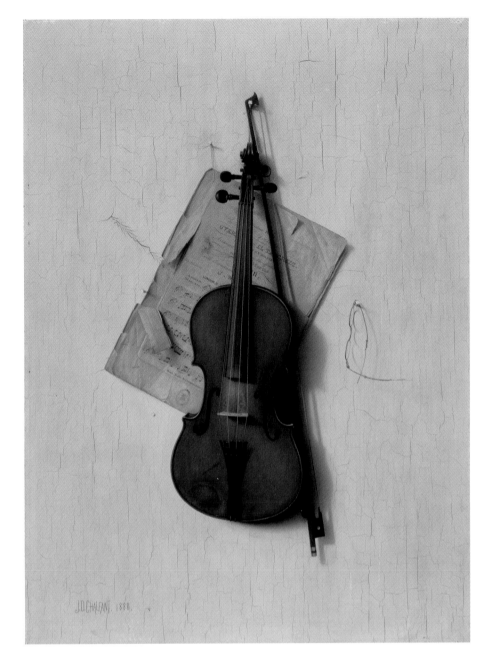

Jefferson David Chalfant, born in Chester County, Pennsylvania, settled in Wilmington, Delaware, in 1879. In the 1880s, he created mostly still-life paintings, but after studying in Paris in the early 1890s, Chalfant's choice of subject shifted to genre scenes and portraiture.

This work belongs to the *trompe l'œil* ("fool the eye") tradition of still-life painting that was popular in late-nineteenth-century America. Indeed, the violin and sheet music seem to protrude three-dimensionally, as if they are real. This painting technique, an inventive approach to representing still-life subject matter, requires excellent technical skills. In *The Old Violin*, Chalfant has created a convincing impression of an old, cracked surface by applying fast-drying shellac while the paint surface was still wet. Chalfant painted four violin compositions—one of which is in the collection of the Metropolitan Museum of Art in New York—probably inspired by a *trompe l'œil* work of the same name by William M. Hartnett, who was considered the American master of the style.

Frederic Edwin Church (1826–1900)
South American Landscape, 1873
Oil on canvas
31 × 48½ in. (78.7 × 123.2 cm)
Gift of the Friends of Art, 1964
DAM 1964-1

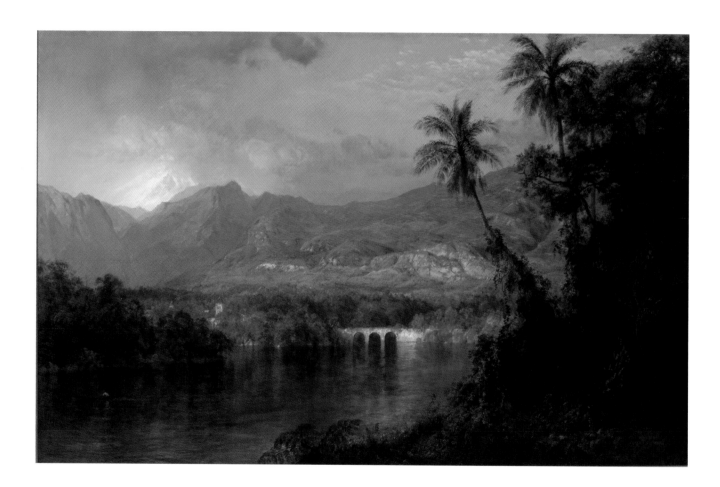

Frederic Church was Hudson River School painter Thomas Cole's pupil. Not actually a school, the Hudson River painters created lush canvases of the American landscape, primarily during the middle decades of the nineteenth century. While Church's early landscape paintings owe much to the influence of Cole, his work from the 1850s onward demonstrates an increased attention to the precise visual effects of weather and nature. Church's interest in scientific accuracy was influenced by the writings of the artist and theorist John Ruskin, who also influenced the Pre-Raphaelite painters.

In 1853 Church made his first visit to South America. He was inspired by the journeys and writings of eighteenth-century German scientist and explorer Baron Alexander von Humboldt. Von Humboldt considered nature to be a living whole that could be represented by the sum of the descriptions—verbal and visual—of its natural phenomena. Church's travels yielded a treasury of diverse sketches and notes, which he later transformed into monumental landscape paintings in his studio. As is the case in many of these paintings, *South American Landscape* depicts a variety of climactic conditions: humid, steamy jungle at the riverbanks and arid mountains, rising up to meet the clouds, in the background. Note the tall steeple of a village church at the far side of the river. Frederic Church often included such structures in his landscapes as a visual pun.

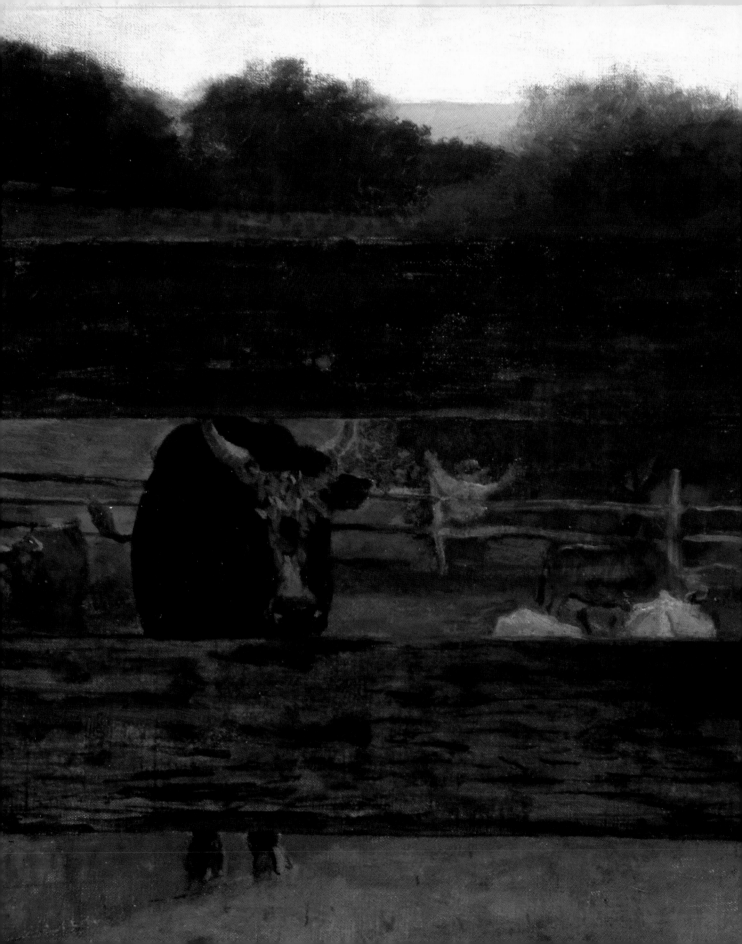

Winslow Homer (1836–1910)
Milking Time, 1875
Oil on canvas
24 × 38¼ in. (61 × 97.2 cm)
Gift of the Friends of Art and other donors, 1967
DAM 1967-2

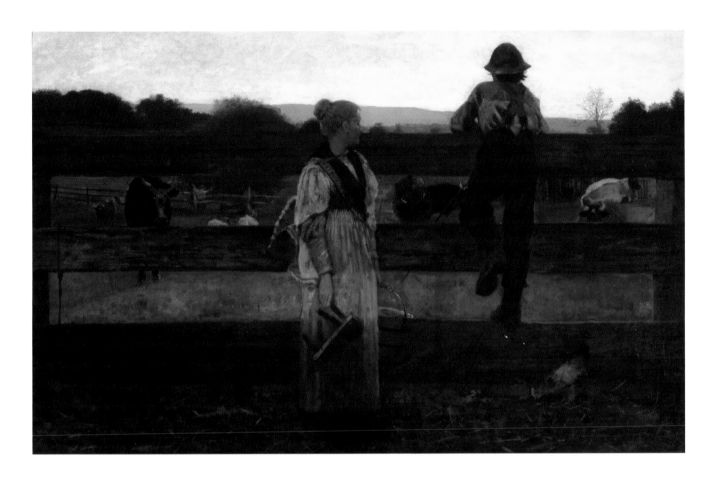

Homer's earliest artistic training came from his mother, and at the age of nineteen he was apprenticed to a lithographer. Following his apprenticeship, Homer was determined to support himself as a freelance illustrator, which he did successfully for the next fifteen years.

During the summers of the 1870s, Homer traveled to various country locations seeking inspiration for his work. What evolved from these journeys were images predominantly focused on scenes of rural life and childhood activities. Homer painted *Milking Time* in the wake of his new freedom after he ceased to make illustrations for popular magazines.

This scene portrays a momentary pause in activity as cows are driven in for milking. The backside view of the boy climbing the corral fence and of the farm woman, whose face turns away, invite us to imagine ourselves standing in as either character. Not merely a peek at American farm life of the 1870s, however, the painting—composed of both revealed and barred views—may also be a commentary about freedom. The planks of fence in the foreground limit the view of the landscape from ground to horizon so that, while we are welcomed into the picture, we are also excluded.

Thomas Wilmer Dewing (1851–1938)
Morning, 1879
Oil on canvas
35 × 59½ in. (88.9 × 151.1 cm)
Special Purchase Fund, 1975
DAM 1975-61

Boston-born Thomas Dewing initially trained as a lithographer and eventually went on to pursue painting. *Morning* was painted in Boston after Dewing's return from Paris, where he studied from 1876 to 1878. Not long after the completion of this painting, Dewing settled in New York City permanently.

In this painting, two fancily clad women sit at the edge of a fountain, blowing long heraldic trumpets to announce the dawn of a new day. Facing the women, two sleek hounds listen attentively to the clarion call.

Morning is constructed of repetitive patterns of compositional tension: the women, their horns, the stone pad, and the tree foliage that surrounds them all point toward the right side of the scene. The dogs, leaning from right to left, provide counter-movement to the composition. The lateral motion and echoed response focus the viewer on the action of women blowing the horns.

Morning was first exhibited in 1880 at the Doll and Richards Gallery in Boston. The painting was considered eccentric and difficult to understand, despite Dewing's intention of creating a delicate and poetic work. A critic of the day, in a review of regional artwork, compared this American painting to "the Burne-Jones school of English painters." The enigmatic quality of the women in this painting would become a hallmark of Dewing's work.

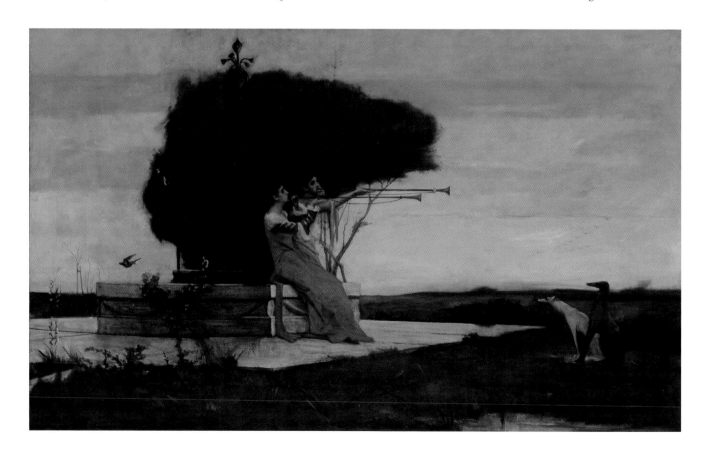

Augustus Saint-Gaudens
(1848–1907)
Head of Abraham Lincoln, 1884–87,
cast *c*.1923
Bronze on marble base
23 × 9 × 12 in. (58.4 × 22.9 × 30.5 cm)
Gift of Rufus and Lorraine Erickson, 2002
DAM 2002-2

The *Head of Abraham Lincoln* is based on the *Standing Lincoln* Saint-Gaudens sculpted for Chicago's Lincoln Park between 1884 and 1887. From the time of the commission, Saint-Gaudens believed that this statue would be important to him personally; Lincoln had been a much-celebrated figure of the artist's youth. In fact, the sculptor had witnessed President-elect Lincoln passing in a carriage in 1860 —a story Saint-Gaudens was fond of retelling. The sculptor's conception of Lincoln's physiognomy was formed from personal memory, photographs of the president, and from a life-cast of Lincoln's face made by sculptor Leonard W. Volk in 1860.

Beyond creating a sculpture of an important person, the challenge Saint-Gaudens faced was to represent the man as an icon. Previous sculptures of President Lincoln generally emphasized episodes from his life. Saint-Gaudens studied numerous books and articles in order to understand Lincoln's personality and political point of view. So moved was the sculptor by what he learned about Abraham Lincoln, that Saint-Gaudens reinvented the stern visage of a homely figure into that of a contemplative and compassionate man. The *Standing Lincoln* was widely acclaimed after its unveiling, not only as a true likeness, but as an archetype of this great man.

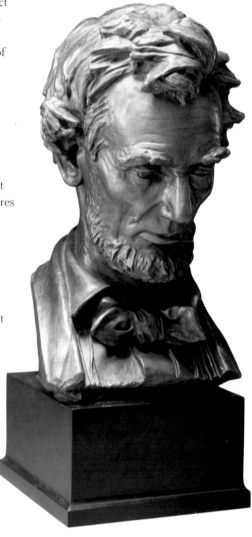

Thomas Eakins (1844–1916)
Franklin L. Schenck, c.1890
Oil on canvas
24 × 20 in. (61 × 50.8 cm)
Bequest of Mrs. Robert Wheelwright, 1969
DAM 1969-1

Thomas Eakins studied painting at the Pennsylvania
Academy of the Fine Arts and, concurrently, studied
anatomy at Jefferson Medical College in his hometown of
Philadelphia. In the fall of 1866, Eakins left for Paris to study
at the École des Beaux-Arts. Upon his return to Philadelphia
in 1876, Eakins began teaching at the Pennsylvania Academy
of the Fine Arts, where he remained until 1886.

After departing the Pennsylvania Academy, Eakins taught
at the Art Students' League of Philadelphia, a student-run
cooperative, from its inception in 1886 until it folded in 1892.
The subject of this portrait, artist Franklin Schenck, studied
with Eakins at the League and also worked as curator for the
school: he lived on and maintained the premises and served as
a studio model. During that time Schenck served as a model
for at least seven paintings by Eakins. In this portrait, Schenck
rests his head on his left hand in a pensive pose. His relaxed
demeanor and the informality of his hair and clothes were
rather uncommon in late nineteenth-century portraiture,
but were understandable, as this was not intended to be a
formal portrait.

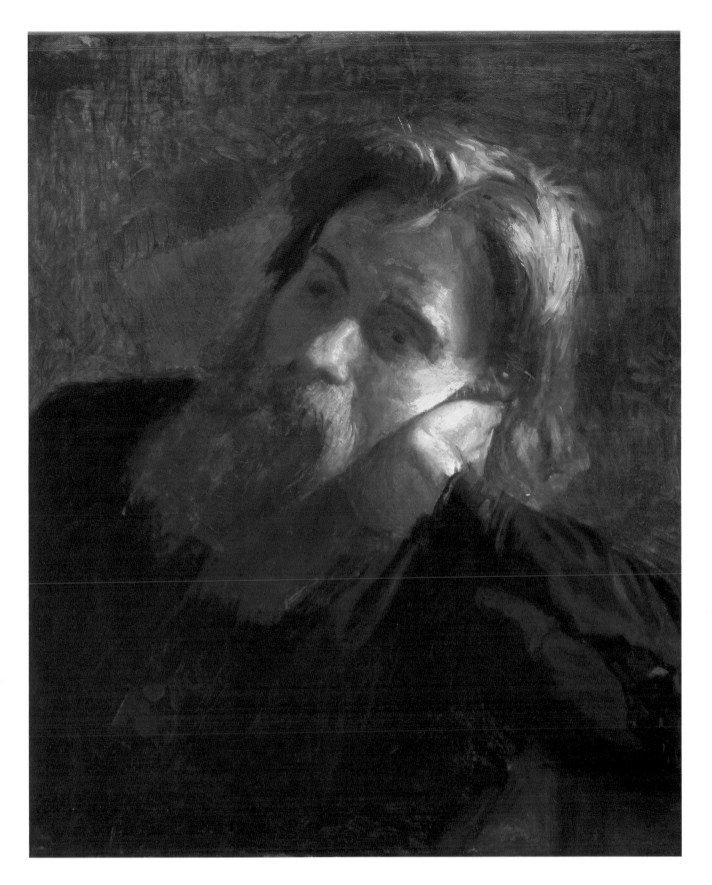

George Inness (1825–1894)
Early Autumn, Montclair, 1891
Oil on canvas
29 × 45 in. (73.7 × 114.3 cm)
Special Purchase Fund, 1965
DAM 1965-1

See detail on page 34

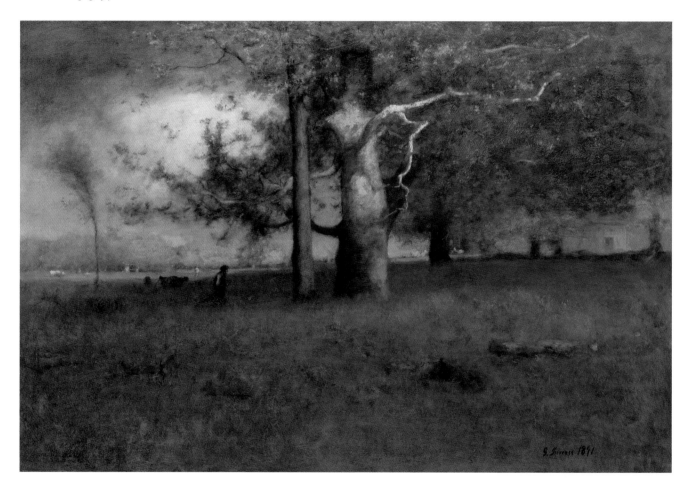

George Inness, born in the Hudson River Valley, was raised in the vicinity of New York City. He taught himself to paint by copying the prevailing style, which was rooted in French-academic traditions and beholden to the landscape styles of such eighteenth-century painters as Claude Lorraine. By the 1860s, Inness's landscape paintings began to be successful due to his penchant for symbolic depictions. In the late 1860s Inness became acquainted with the religious precepts of Emmanuel Swedenborg, who believed that the world's mundane and spiritual qualities were tied. The correspondence between the natural and mystical worlds could be described by the maxim, "as above, so below."

Early Autumn, Montclair, in which the subject matter is suggestive but non-specific, is most importantly an example of pictorial poetry. The centered foreground trees are spotlighted, even though the overall scene appears unfocused. Like the Impressionists, Inness observed nature closely and sought to express the season, weather, and lighting conditions of the scene. Although Inness began his paintings in nature, he completed his work in his studio—unlike the Impressionists—relying on his memory and infusing his imagination into the work to create luminous expressions of the spirituality of nature.

John Henry Twachtman (1853–1902)
Sea Scene, 1893
Oil on canvas
28 × 34 ⅛ in. (71.1 × 86.7 cm)
Special Purchase Fund, 1963
DAM 1963-21

Born in Cincinnati, Twachtman initially trained with American painter Frank Duveneck. Following in his teacher's footsteps, Twachtman began to study in Europe, beginning in Munich, in 1875. Between 1883 and 1885 he studied at the Académie Julian in Paris. After his return to the United States in 1878, Twachtman's palette began to lighten, and his mode of painting took on a modified Impressionist style that became his specialty.

In *Sea Scene*, the indistinct nature of Impressionist-style paint application convincingly conveys the churning froth of the crashing waves on the rocky coast. Twachtman emphasizes the peril of such wild waves by extending the waterscape through the foreground to the bottom edge of the canvas and diminishing the adjacent landforms. He employed highly textured brushwork, mixing his colors directly on the canvas, to create the impression of the scene as he saw it before him.

Twachtman, according to fellow artist and associate Childe Hassam, painted the essential nature of a thing or place. In *Sea Scene*, the speedily executed brushstrokes used to express the violent, ever-changing condition of breaking waves are contrasted by the static brushstrokes that describe the seemingly immutable rocks.

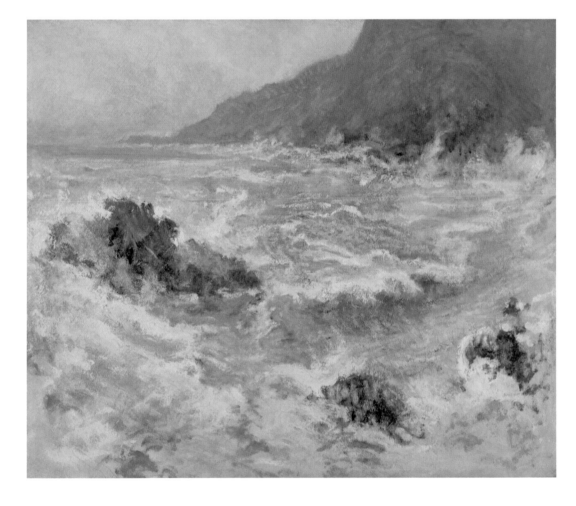

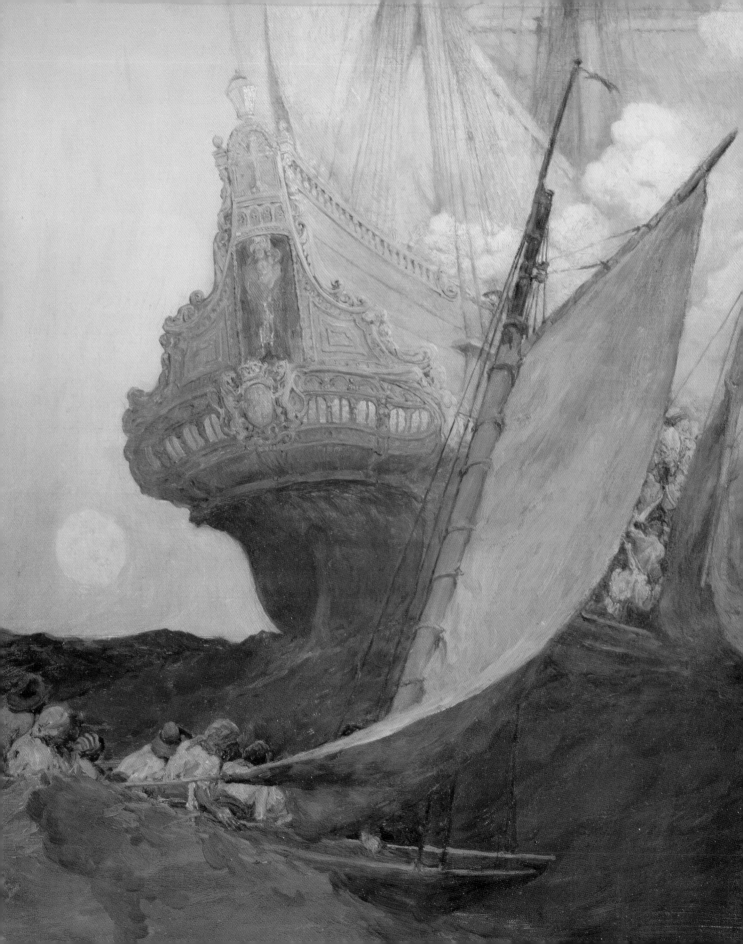

3

HOWARD PYLE
AND HIS STUDENTS

Born in Wilmington, Delaware, in 1853, Howard Pyle was the son of William Pyle, a leather manufacturer. His mother, Margaret Pyle, stimulated his artistic interests by reading to him, making available fine books and illustrated periodicals, and encouraging him to write and draw. She also imparted a strong sense of both spirituality and imagination—and the connection between the two—that characterized her Swedenborgian religious beliefs.

Pyle studied art briefly in Philadelphia and, at age nineteen, began giving art lessons in Wilmington. In 1876 he published his first illustrated poem in the July issue of *Scribner's Monthly*. Over the next thirty years, Pyle's more than three thousand illustrations appeared not only in numerous books, but also in major magazines, including *St. Nicholas*, *Harper's Weekly*, *Harper's Monthly*, and *McClure's*. For many publications, he also wrote the stories he illustrated. His work encompassed historical fiction and non-fiction, romance, European medieval themes, adventure, folk and fairy tales, poetry, and whimsical narratives for children.

Although Pyle spent a few years in New York City, he lived most of his life in his teaching studio in Wilmington. He taught at the Drexel Institute of Art, Science and Industry (now Drexel University) and held a summer school in Chadds Ford, Pennsylvania. Pyle's "students" were mostly practicing illustrators, many of them already published, who came for critiques rather than for lessons as such. Pyle also exhibited and lectured throughout the United States. In 1910, determined to improve his mural painting by studying those of the Italian Renaissance masters, Pyle sailed for Italy. A year later he died in Florence, where he is buried.

With increasing literacy and leisure time, the late nineteenth century saw an efflorescence of illustrated books and magazines. Pyle brought to his work an immediacy often lacking in earlier American illustration. A love of theater helped inspire his philosophy and practice of illustration. Through his "theory of mental projection," as he called it, Pyle intensely imagined the experience he was depicting. By studying facial construction, he perfected ways of portraying the essence of human feelings. Devices such as exaggerated gestures, upward viewpoints to suggest sweeping action, and evocative lighting to create mood all lent a riveting quality to his work. A masterful colorist, Pyle imbued his paintings and drawings with drama and emotion. His dedication to accurate historical detail, combined with a Romantic sensibility, lent a convincing realism to his scenes. Pyle used these talents to create compelling illustrations that still give us, as he once noted, "a vivid flash of real truth."

Mary F. Holahan
Registrar

Opposite:
Howard Pyle (1853–1911)
Attack on a Galleon, 1905
Detail from page 57

Howard Pyle (1853–1911)

The Fight on Lexington Common, April 19, 1775, 1897

Illustration for "The Story of the American Revolution," by Henry Cabot Lodge

Scribner's Magazine, January 1898

Oil on canvas

23¼ × 35¼ in. (59.1 × 89.5 cm)

Museum Purchase, 1912

DAM 2024

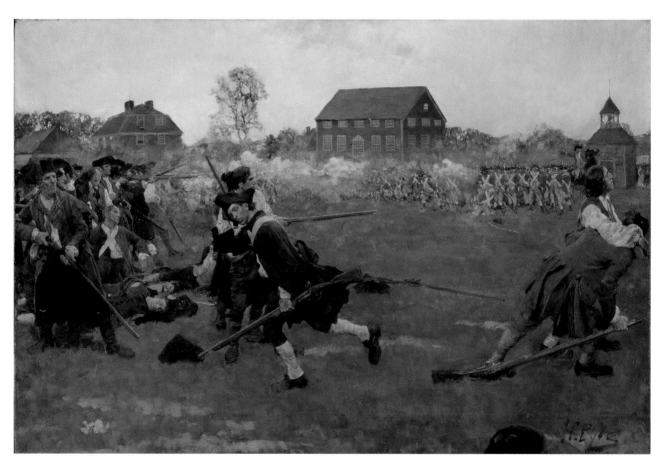

In the late nineteenth century, during a period of rapid social change, the American Revolution became a touchstone of national values. Following the United States Centennial Exposition of 1876 in Philadelphia, publishers responded to popular interest in the nation's founding.

In 1897 Howard Pyle was commissioned to produce twelve illustrations for Henry Cabot Lodge's "Story of the American Revolution," serialized in *Scribner's Magazine* throughout 1898.

The fight on Lexington Common was one of the initial skirmishes of the American Revolution. En route from Boston to suppress rebellious colonists at Concord, British troops encountered seventy-seven American militiamen and their supporters on Lexington Green. American bravery could not overcome British force, and the British forged ahead to Concord. But victory was short-lived for the British, as American patriots at Concord forced the regulars to withdraw. As the British marched back to Boston, they were assaulted by what would become the Americans' best tactic: firing from houses, trees, and stone walls. The Battles of Lexington and Concord solidified colonial resistance.

Pyle infuses the battle scene with the confusion and pathos of dying and wounded Americans. In spite of the military rout, their expressions and postures speak of their determination and dignity. The scene is one of national spirit as well as that of a historical event.

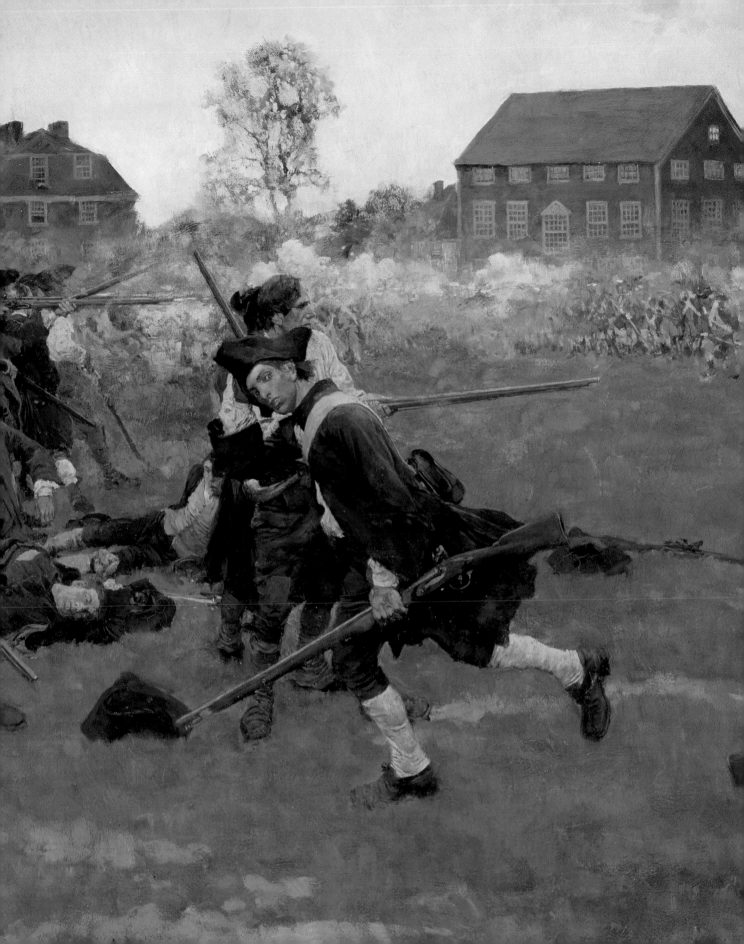

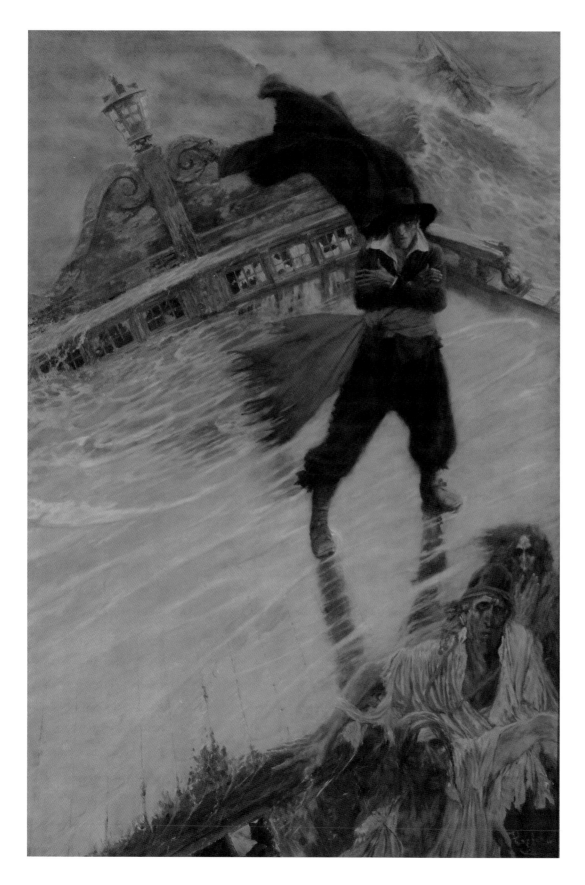

Howard Pyle (1853–1911)
The Flying Dutchman, 1900
Collier's Weekly, December 8, 1900
Oil on canvas
71⅜ × 47½ in. (181.3 × 120.7 cm)
Museum Purchase, 1912
DAM 86

According to the legend of the Flying Dutchman, a Dutch sea captain encountered a storm while sailing around the Cape of Good Hope, at the tip of Africa. Ignoring the pleas of his crew to avoid the eye of a storm, the captain cursed God and swore to overcome the sea. The ship foundered, killing all on board. As punishment, the mariner, his crew, and his ship were doomed to sail near the Cape forever. Thereafter, the sight of the phantom ship boded disaster for all who saw it. In variants of the tale, including the Wagner opera *Der Fliegende Holländer*, the Devil gives the captain hope of salvation by allowing him to return to land every seven years to seek the woman whose faithful love will save him from his cursed seafaring.

Pyle's painting distills several folkloric and Romantic themes: the rootless wanderer, the outsider set against fate, the supernatural and the power of nature, all placed within a cauldron of emotional torment. The lurid colors of the sky and undulating sea envelop the ghostly broken ship. We see the spectral crew as if through a distorting mist, their dismal faces elongated and their clothing tattered. The captain, however, still holds his upright pose against the gale. His skeletal hands and ghastly eyes proclaim both his defiance and his doom.

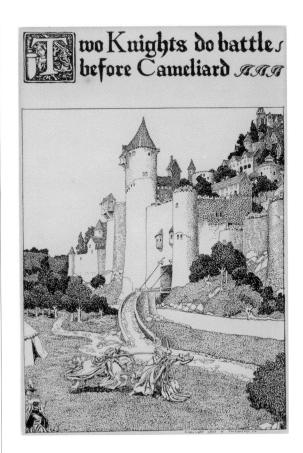

Howard Pyle (1853–1911)
Two Knights do battle before Cameliard and title with illustrated initial T, 1903
Illustration for "The Story of King Arthur and His Knights,"
by Howard Pyle
St. Nicholas, March 1903
Ink on board
14¼ × 10¼ in. (36.2 × 26 cm)
Museum Purchase, 1912
DAM 1910/1911

Pyle was an inheritor of the nineteenth-century revival of historical periods. Alfred Lord Tennyson's *Idylls of the King*, a poetic elegy written in several chapters between 1859 and 1874, was a literary hallmark of the Gothic revival. Tennyson's idealized and romantic retelling of the Arthurian tales of the British Middle Ages fascinated American readers of both popular and classical literature.

Pyle wrote and illustrated four Arthurian volumes, *The Story of King Arthur and His Knights*, *The Story of the Champions of the Round Table*, *The Story of Launcelot and His Companions*, and *The Story of the Grail and the Passing of Arthur*. Pyle enlivens his Arthurian images with a decorative verve and a flair for dramatic composition. Here, the castle turrets, reminiscent of those Pyle would have seen in reproductions of medieval prints, rise up the hillside. Below, curvilinear lines dominate the view: the road to the drawbridge, the winding path, and the mantles of jousting knights on horseback. The steeple cut off at the top right and the audience partly depicted at the lower left imply a far wider scene than the artist has drawn. Fine detail and ample space complement each other. Pyle's descriptive ink lines animate the legendary world of Arthur and his realm with a lively and elegant spirit.

Howard Pyle (1853–1911)
The Buccaneer was a Picturesque Fellow, 1905
Illustration for "The Fate of a Treasure Town," by Howard Pyle
Harper's Monthly, December 1905
Oil on canvas
30 ½ × 19 ½ in. (77.5 × 49.5 cm)
Museum Purchase, 1912
DAM 982

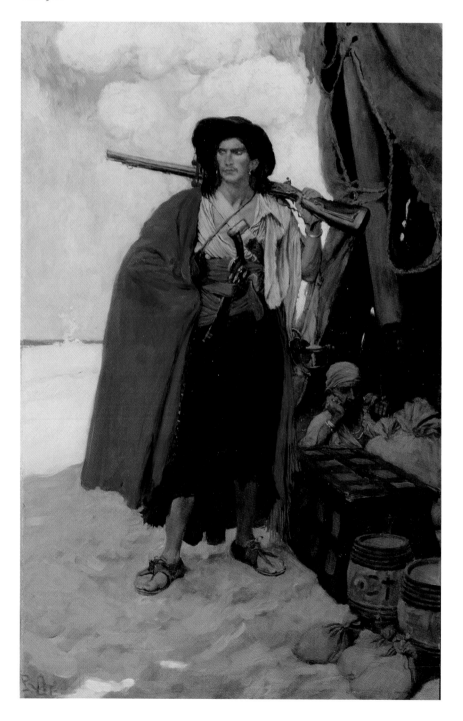

Pyle's pirate stories ranged from high-seas dramas in Caribbean waters to dockside exploits in New York City. "The Fate of a Treasure Town" describes the dangers of Colombia's Cartagena coast.

Though represented in only a small segment of Pyle's work, pirates captured (and still hold) the public's imagination. Pyle's pirate figures, which he based on historical and folkloric reports, often have a dashing yet sinister demeanor. The stance and expression of this handsome buccaneer express freedom and rebellion; he epitomizes the romantic outlaw. With weapons at the ready, and cloaked in brilliant red against his domain of sea and sand, he poses casually while keeping a wary eye for intruders. His languid and bejeweled companion guards the treasure.

To Pyle, the pirate's charm and ill-gained opulence did not mitigate his murderous crimes. Readers may, Pyle noted, "read between the lines of history this great truth: Evil itself is an instrument toward the shaping of the good. Therefore the history of evil as well as the history of good should be read, considered, and digested."

Howard Pyle (1853–1911)
Attack on a Galleon, 1905
Illustration for "The Fate of a Treasure Town," by Howard Pyle
Harper's Monthly, December 1905
Oil on canvas
29½ × 19½ in. (74.9 × 49.5 cm)
Museum Purchase, 1912
DAM 983

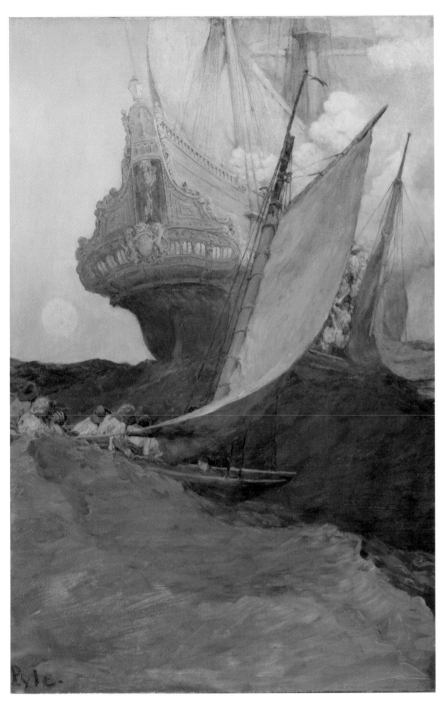

Pyle biographer Charles C. Abbott wrote that the four illustrations in "The Fate of a Treasure Town" were at the time "the sensation of the magazine world," each one "marvelously rich in color, but not garish; dramatically stirring and vividly romantic."

In "The Fate of a Treasure Town," Pyle's lyrical descriptions of "a wonderful sea of sapphire and emerald" blend with a stark narrative of "sack and ruin." *An Attack on a Galleon* is a sequential presentation of a pirate attack: in the foreground, a small boat with windswept sail plunges through almost-black, shadowy waves toward the massive galleon; in the middle ground, another lethal craft has already disgorged its pirates; behind the action, billowing smoke, strikingly illuminated by gunfire, indicates the assault overcoming the crew. A majestic icon on the galleon's prow, as yet unscathed, looks down upon the ruthless action.

Pyle's library included Captain Charles Johnson's 1734 book *A General History of the Lives and Adventures of the Most Famous Highwaymen, Murderers, Street Robbers, etc...to which is Added a Genuine Account of the Voyages and Plunders of the Most Notorious Pyrates.* Besides such literary accounts, local lore may have inspired the artist. The Delaware coastal towns of Lewes, Rehoboth, and Cape Henlopen were all favorite haunts of pirates in the early eighteenth century.

See detail on page 50

Howard Pyle (1853–1911)
The Coming of Lancaster, 1908
Illustration for "The Scabbard," by James Branch Cabell
Harper's Monthly, May 1908
Oil on canvas
35½ × 23¼ in. (90.2 × 59.1 cm)
Museum Purchase, 1912
DAM 1039

Pyle produced two illustrations for James Branch Cabell's "The Scabbard," a fictional episode based on English history. In 1399 Henry of Lancaster deposed his cousin King Richard II to become King Henry IV. Uprisings in support of the imprisoned Richard led Henry to have him murdered. Cabell's imaginary re-telling of history has the deposed Richard flee to Wales where, disguised as a shepherd, he falls in love with Branwen, an innocent country girl. After some time, Henry appears with his soldiers determined to kill his escaped cousin. Richard swears in turn to kill Henry, but then realizes that he would rather spend his life in pastoral contentment with Branwen. No longer regarding Richard as a threat, Henry then departs.

Pyle depicts the moment in which the imposing Henry of Lancaster recognizes Richard in his peasant guise. Compared to Henry's commanding presence, Pyle's Richard, with Branwen cowering at his side, reveals a different psychological portrait: rather than a determined warrior, he seems a moody recluse. He has the haunted face and awkward pose of a conflicted man. His introspective demeanor varies from Shakespeare's Richard II, who finds himself without an identity once he loses his crown. Pyle's Richard finds his worth in love, a plot resolution embodying Victorian, rather than Elizabethan, ideals.

Howard Pyle (1853–1911)
Marooned, 1909
Not published
Oil on canvas
40 × 60 in. (101.6 × 152.4 cm)
Museum Purchase, 1912
DAM 3322

In *Marooned*, the narrative resides, not in the pirate's actions or character but in his state of hopeless abandonment. His face is hidden as if his expression, reflecting the brutality of his fate, would be too difficult for the viewer to bear.

Marooning was the most extreme punishment for violators of the pirates' self-imposed code of conduct. Stealing from fellow crew or deserting one's post in battle, for example, merited marooning: the pirate would be put ashore on a deserted sand bar with a day's supply of water, without food or shelter, but often with a loaded pistol. This pirate's gold buckles and buttons, his tasseled swashbuckler's hat, and the rich red brocade draped gracefully behind him recall his forever-lost place in the treacherous pirate hierarchy.

The inescapable sand and immense burning sky intensify the painting's monumental scale and emotional impact. The tension of the pirate's interlocked fingers foreshadows the drawn-out agony of madness, to be followed by death from thirst and starvation. No wind stirs the sea, almost lifeless at the horizon, its surf barely and silently breaking. Birds pass by without alighting. Pyle has given us, not only a portrait of the end of an adventurer's life but a commentary on human tragedy.

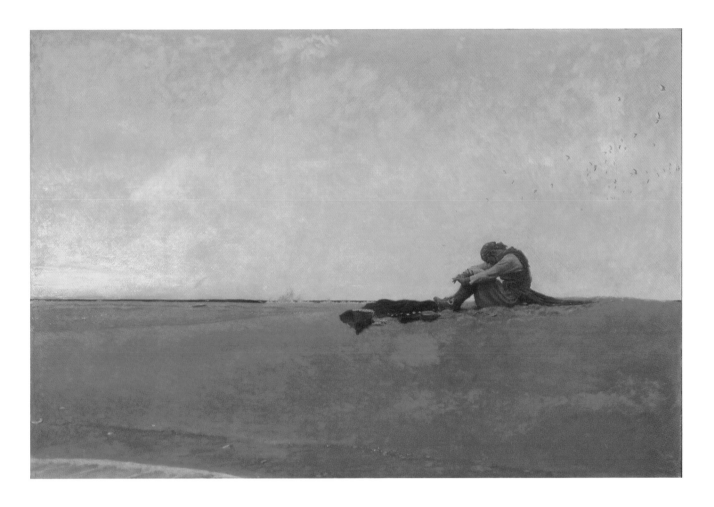

Howard Pyle (1853–1911)
A wolf had not been seen at Salem for thirty years, 1909
Illustration for "The Salem Wolf," by Howard Pyle
Harper's Monthly, December 1909
Oil on canvas
17½ × 29½ in. (44.5 × 74.9 cm)
Museum Purchase, 1912
DAM 1104

One of Pyle's favorite subjects was the early American period. "The Salem Wolf" is a mélange of history and folklore from the days of the Salem witch trials. It includes fragile young girls, untrustworthy suitors, an apparent witch, a severe clergyman, and, of course, a menacing wolf. The plot brings the characters to a sad or violent end, a device Pyle used in adult stories but rarely in children's ones, in which the story generally ended either happily or with a clear moral message.

As an artistic work, the painting stands perfectly well by itself, something characteristic of Pyle's best illustrations. The colonists huddling under a leaden sky seem the essence of fear—physical and psychological. Spellbound, they contemplate the animal, which stares malevolently back, its fangs etched against the sky. The composition is particularly striking, with its almost overpowering expanse of snow and sky, in contrast with the bare trees and bright yellow strip of horizon. Each face is a portrait, making the aura of suspense even more poignant. The painting is a masterful evocation of the superstitions, hardships, and threats of seventeenth-century Massachusetts.

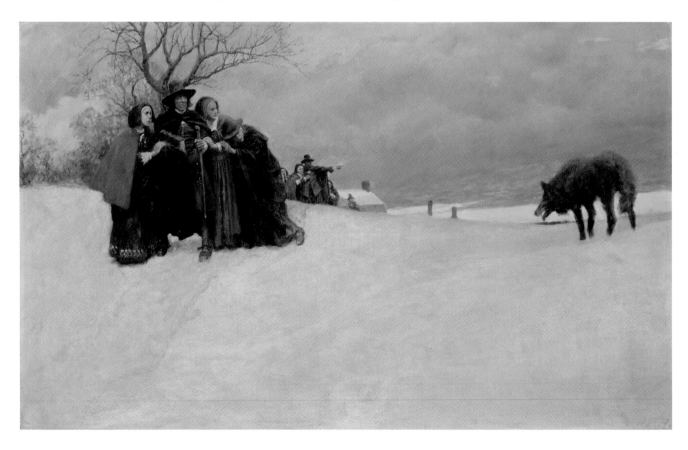

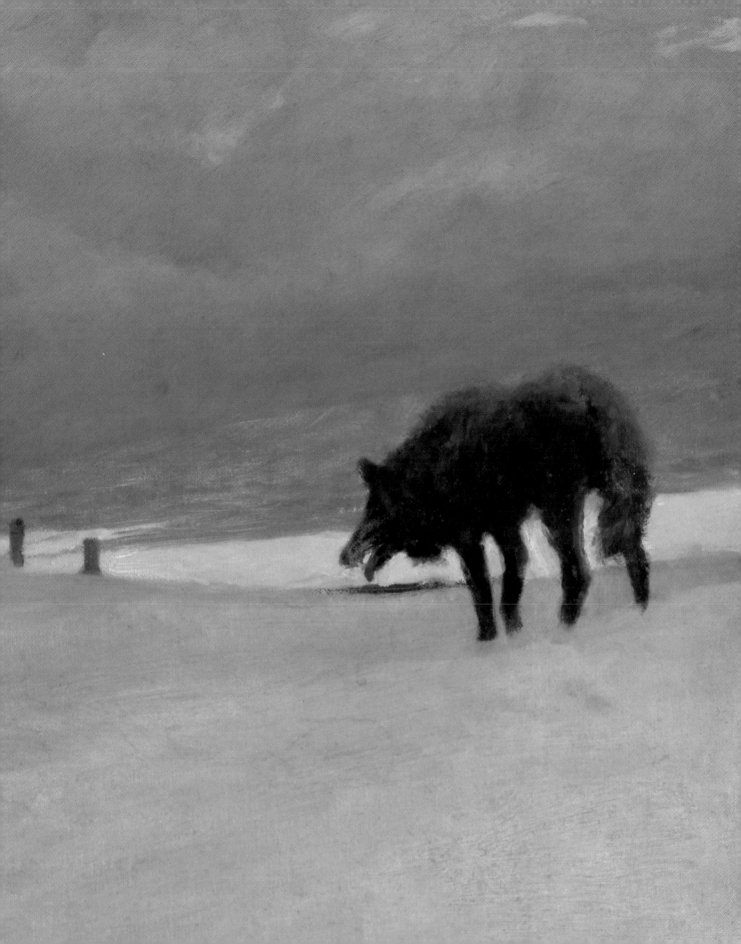

Howard Pyle (1853–1911)
The Mermaid, 1910
Not published
Oil on canvas
57⅞ × 40⅛ in. (147 × 101.9 cm)
Gift of the Children of Howard Pyle in Memory
of Their Mother, Anne Poole Pyle, 1940
DAM 3324

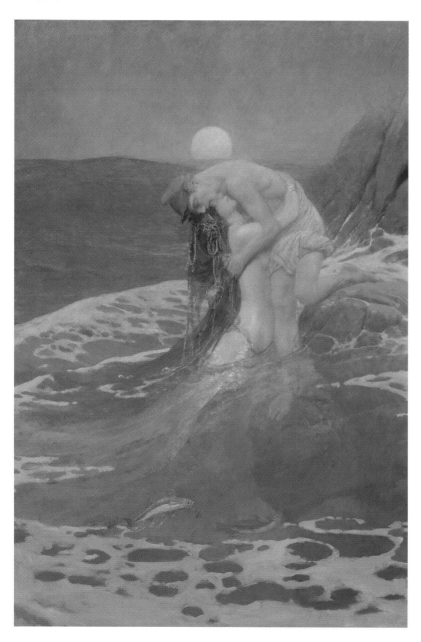

Pyle had left this painting in his studio when he left for Italy—the place of his death—in 1910. Because it was found on his easel, it is probable that he did not consider it finished. His student Frank Schoonover later painted the fishes and the crab in the foreground.

The mermaid is an enduring figure in the mythology of many cultures. In the European art and literature of the eighteenth and nineteenth centuries, with which Pyle would have been familiar, she is the *femme fatale* of the deep, seducing earthbound men and ultimately drowning them.

Pyle's mermaid and her victim recall the paintings of Pre-Raphaelite artists Dante Gabriel Rossetti and Edward Burne-Jones. Her full, red mouth, its expression animated but ambiguous, and her luxuriant hair are reminiscent of Rossetti's *Veronica Veronese* and *La Bella Mano*. The man has the exaggerated Rossettian mouth and heavy features favored by such artists as Burne-Jones. Because Pyle's wife was a cousin of Pre-Raphaelite collector Samuel Bancroft, Jr., it is entirely likely that Pyle saw and appreciated the collection. With its many features atypical of Pyle's earlier work, and because it was apparently not intended for publication, *The Mermaid* may suggest a foray into different stylistic and psychological explorations that were cut short by his sudden death.

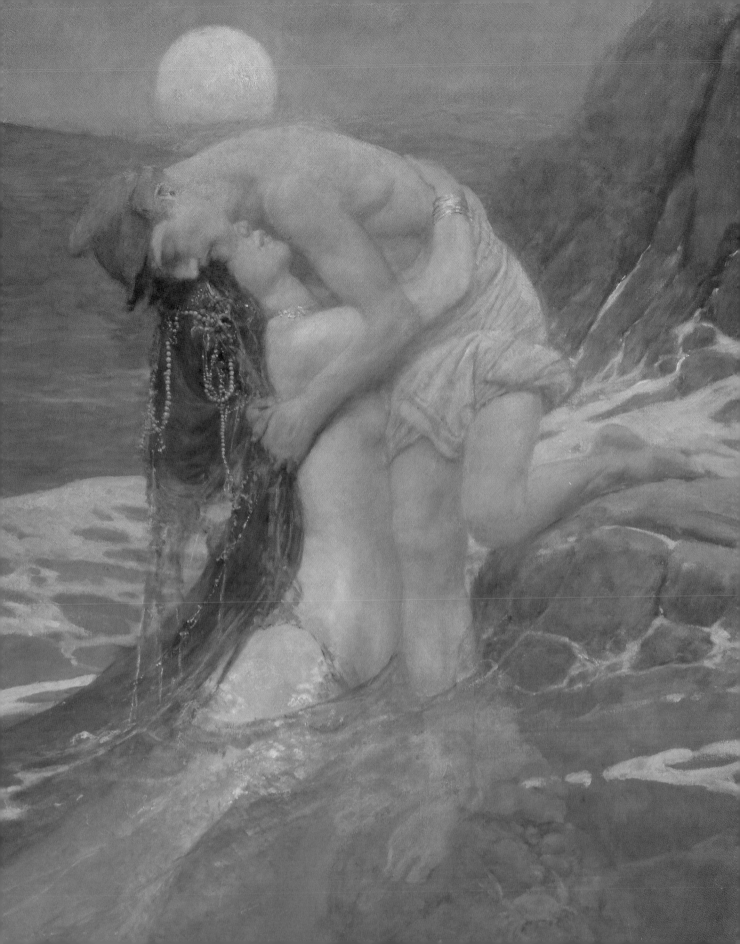

Frank Earle Schoonover (1877–1972)
Hopalong Takes Command, 1905
Illustration for "The Fight at Buckskin," by Clarence Edward Mulford,
Outing Magazine, December 1905
Oil on canvas
30 × 20 in. (76.2 × 50.8 cm)
Bequest of Joseph Bancroft, 1941
DAM 1942-13

Schoonover was a student at the art school of the Drexel Institute when he received scholarships to Pyle's school in Chadds Ford, Pennsylvania for the summers of 1898 and 1899. By 1906 he had established a studio in Wilmington, Delaware.

Known especially for his depictions of outdoor adventure stories and tales about the Canadian far-North and the American West, Schoonover illustrated for many major American writers, including Jack London and Zane Grey. In this illustration for Clarence Edward Mulford's popular Hopalong Cassidy series, the subject was the illiterate, whiskey-drinking cowhand nicknamed for his limp, and not the matinée-idol character of the later films. In "The Fight at Buckskin," the locals stage a chaotic siege in which Hopalong ends up in a barn, perched on a ledge. His vulnerable position is short-lived and Hopalong survives to fight another day.

Schoonover's mastery of realism is evident in the scorched, bullet-riddled wood and Hopalong's dry leather chaps and dusty hat. The cowboy's face, mostly shielded from the searing sun, has the weathered look of a man worn down by the relentless violence of the Old West.

N. C. [Newell Convers] Wyeth
(1882–1945)
However, after six days o' restin' up,
with salubrious fruits an' wines an' the
most melojus concerts, my cap'n
broaches the cause of why we're callin'
on the Don Hidalgo Rodreego
Cazamma, 1915
Illustration for "The Medicine Ship,"
by James B. Connelly
Scribner's Magazine, December 1915
Oil on canvas
39½ × 31¾ in. (100.3 × 80.6 cm)
Special Purchase Fund, 1920

DAM 1920-3

N. C. Wyeth arrived in Wilmington from Boston in 1902 to study with Howard Pyle. Throughout his life, Wyeth struggled to balance illustration with easel paintings. He illustrated "The Medicine Ship" in 1915; the same year, he wrote to a fellow artist, "I determined to launch into purely illustrative work with no turning aside to tease the muse along." Nonetheless, this painting, though it serves its narrative purpose, was executed in a rather impressionistic style and palette evident in some of Wyeth's easel paintings.

The caption sets the scene in flashback, as an old salt remembers his days as cabin boy on a "medicine ship." In the palatial home of South American plantation owner Don Hidalgo, Bill Hickey, captain of the ship *Tropic Zone*, is discussing with the landowner a plan to bottle and sell a medicinal tonic derived from the swamp root that grows on the plantation.

Exotically dressed musicians provide a serenade. The business transacted, the sailors prepare to sail home when a revolution breaks out—an event foreshadowed by the military attire of the servants. The uprising sets the stage for romance between the ship owner's son and Don Hidalgo's daughter. Adventure, suspense, romance, and humor create an entertaining visual and literary narrative.

Gayle Porter Hoskins (1887–1962)

You can't leave her here to suffer, whether you want to or not, you have to do it, 1925

Illustration for "Roads of Doubt," by William MacLeod Raine

Woman's Home Companion, February 1925 (frontispiece)

Oil on canvas

26 × 36 in. (66 × 91.4 cm)

Gayle and Alene Hoskins Endowment Fund, 1979

DAM 1979-38

In 1907 Hoskins began his studies at Pyle's school of illustration in Wilmington. By the 1920s, he was a versatile and prolific illustrator. Here, a boulder has stranded the stylish Joy Elliot and her suave fiancé, Winthrop Ordway, on a mountain pass at night until Robert Hallack, an engineer in Joy's father company, discovers them. Ordway, misunderstanding Hallack's response to his request that the engineer give the couple a ride, rebukes Hallack for refusing. Hallack explains that he will take Joy but not Ordway, who the reader knows to be a notorious cad. Joy faces the dilemma of choosing between the physical and moral peril of staying all night with Ordway or returning to town with Hallack.

Her decision to go with Hallack foreshadows her later decision to leave Ordway and marry Hallack, and signifies her maturity and rejection of the "fast" life.

Hoskins's theater experience helped him to establish the backgrounds of the characters through costume, and to create dramatic lighting effects. Joy, in her elegant low-waisted chemise, headband and fur coat, is a classic flapper. Ordway's dandified suit and coat place him in contrast to Hallack, who is attired in plain work clothes. The car's headlights emphasize its role in the mobility of modern life—the mobility that challenges the heroine of "Roads of Doubt."

Stanley Massey Arthurs (1877–1950)
New Year's Eve (also called *The Night Watch*), 1928
Illustration for a Brown & Bigelow calendar (month of January)
Oil on canvas
36 × 27 in. (91.4 × 68.6 cm)
Louisa du Pont Copeland Memorial Fund, 1930
DAM 1930-1

Of Pyle's students, Stanley Arthurs was probably the most faithful to the belief that historical verisimilitude should complement the illustrator's imagination.

In *New Year's Eve*, a New England sentry performs his duty of knocking on doors, announcing the time and weather. He calls at an inn, where, as the swaying sign suggests, his declaration will doubtless be "cold and windy."

Arthurs had an abiding interest in the evocative impact of vibrant colors. Here, the intense blue-green comes from the night sky and the illumination of the green door. The sky is replete with shades of purple, blue, and green, which create flickering effects. The lantern casts shimmering pink light on the snow. Arthurs's palette heightens the mood and emotional effect, rather than describing the scene with visual fidelity. Color, then, with its suggestive power, balances and complements Arthurs' devotion to correct historical detail, which is apparent in the character of the watchman.

The pleasures and dangers of eighteenth-century America are implicit in *New Year's Eve*. The warm light of the inn, the dependable sentry, and the picturesque town conjure up the contentment of a peaceful evening. But the watchman's emergency rattle, suggesting the need for constant vigilance in case of fire, lost travelers, and public insurrections, reminds the viewer of town dwellers' vulnerability in early America.

AMERICAN ILLUSTRATION

I n the nineteenth century, Americans viewed more illustration than they did any other art form. By mid-century, America's burgeoning middle class, coupled with nearly universal elementary education, led to an increased interest in periodicals. By the end of 1850, the combined circulation of the most famous illustrated weeklies, *Ballou's Pictorial*, *Harper's Weekly* and *Frank Leslie's Illustrated Newspaper*, exceeded a quarter of a million copies per week. Over the next two decades, the number of periodical titles produced in the United States more than quadrupled, from seven hundred to more than three thousand.

Mid-century newspaper and magazine illustration was dependent upon the transformation of an artist's drawing into a wood-block engraving by an intermediary craftsman. Rarely did illustrators also do their own wood-carving. As readership and publication volume increased, so too did the need for talented artists to provide the drawings to be turned into wood-engraved illustrations. Many artist–illustrators became famous: Thomas Nast, Winslow Homer, Howard Pyle, N. C. Wyeth, Charles Dana Gibson, and Maxfield Parrish.

Between the 1870s and 1900, technological developments in the reproduction processes allowed for greater naturalism in the illustrators' images—reproducing line, shade, and color with greater ease and accuracy. By the mid-1880s wood-block engravings ceased to be produced. Advances in color printing and photomechanical reproduction soon revolutionized the quality of images it would be possible to produce in the pages of the popular press.

Until that time most illustrators had learned their craft on the job as staff artists for newspapers and magazines. In 1894 Howard Pyle recognized the need for thoroughly trained illustrators and began to teach at the Drexel Institute in Philadelphia, where he remained until 1900. By 1895 Pyle had also established his own schools in Chadds Ford, Pennsylvania, and in Wilmington, Delaware.

Joyce K. Schiller
Curator

Opposite:
Elizabeth Shippen Green (1871–1954)
The Library, *Harpers Monthly*, August 1905
Detail from page 73

Thomas Nast (1840–1902)
The Fat Boy
Cover for Dickens' *The Pickwick Papers*,
a McLaughlin Bros. publication, *c*.1869
Ink and watercolor on paper
10½ × 9 in. (26.7 × 22.9 cm)
Gift of Helen Farr Sloan, 1978
DAM 1978-39

Born in Bavaria, Nast immigrated to the United States in 1846 with his family. By the age of fifteen, Nast was creating illustrations for *Frank Leslie's Illustrated Magazine*. He worked freelance until 1862, when he joined *Harper's Weekly* as a staff artist. Nast is renowned for his political cartoons that lampooned New York City's famously corrupt Tammany Hall and for his now-classic image of Santa Claus.

Nast was commissioned for this design and other illustrations for the publication of an excerpt of Charles Dickens' novel *The Pickwick Papers*, a work originally written as a series of literary sketches, and illustrated by caricaturist Robert Seymour. In his own rendition, Nast emphasizes the Fat Boy's great girth by buttoning the front of his cut-away coat tightly across his chest. The diagonal run of buttons to either side of the closure, seen in both views, indicate that the coat lapels were meant to have been buttoned back to reveal the form of a slimmer man's chest and waistcoat. The Fat Boy's skin-tight breeches, or pantaloons, visible in the inset illustration, expose his navel through the thin legging fabric. The misspelling of Dickens' name in this work suggests that this was probably not the final version of *The Fat Boy*.

Edward Penfield (1866–1925)
Harper's February
Poster for *Harper's*, 1896
Lithograph on paper
19 ¾ × 10 ⅞ in. (50.2 × 27.6 cm)
Gift of Walker Penfield, 1969
DAM 1969-5

Penfield studied at the Art Students League intermittently for several years before, at the age of twenty-four, he was appointed art editor for the Harper and Brothers periodicals *Harper's* magazine, *Harper's Weekly*, and *Harper's Bazaar*. In addition to serving as art editor, Penfield also designed monthly promotional posters for *Harper's* from 1891 to 1901.

Contemporary European posters and Japanese wood-block prints influenced Penfield's work. European poster artists were adopting many new artistic concepts into their commercial poster designs, including the abstract visual language of Japanese prints.

Like most of his *Harper's* posters, *Harper's February* is an uncomplicated composition. The page is constructed of areas of simple tones that often perform a double duty. The blue of the masthead area is also the blue of the landscape's sky, for example. The field of the middle to foreground is composed of a simple, stippled gray-tone spatter that darkens to define distance. Despite using broad flat colors for the woman's skirt and jacket, Penfield teasingly deploys the pouf of her sleeve and edge of her skirt into the margin, defying the spatial construct of the poster.

J. C. [Joseph Christian] Leyendecker
(1874–1951)
Cashmere Bouquet, late 1890s
Chalk, crayon, and gouache on paper
24½ × 18½ in. (62.2 × 47 cm)
Gift of Helen Farr Sloan, 1984
DAM 1984-19

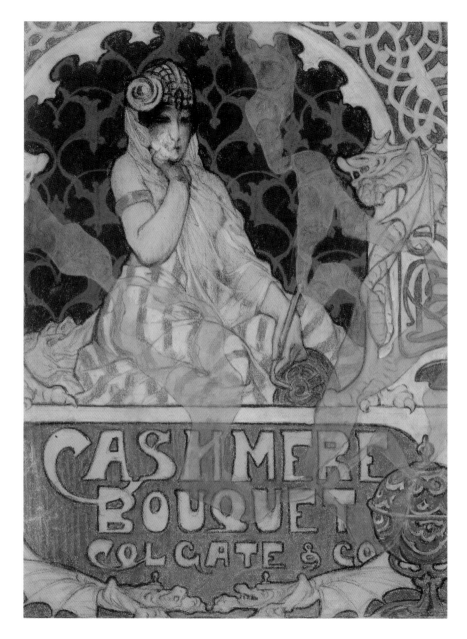

J. C. Leyendecker and his younger brother, artist–illustrator Frank Xavier Leyendecker, were born in a small town in southern Germany. The family immigrated to the United States in 1882. At the age of sixteen, Leyendecker was apprenticed to a Chicago engraving firm. With his earnings, he studied art at the School of the Art Institute of Chicago and eventually went to Paris to study at the Académie Julian.

Leyendecker is best known for his image of the all-American man used in countless Arrow Collar and Shirt advertisements, which he illustrated from 1907 through 1931. He also created advertisement illustrations, as well as cover designs for the

Inland Printer and *The Saturday Evening Post*. This advertising design, *Cashmere Bouquet*, plays on the exotic appeal of the once-rare cashmere. In this study, Leyendecker allows us a view, through the opening in a patterned wall, of a beautiful harem girl holding the mouthpiece of a water pipe, or hookah, in her left hand. The smoke wafting up from the hookah subtly overlays the scene and some of the letters in the identifying title.

Elizabeth Shippen Green (1871–1954)
The Library
For "The Mistress of the House"
Harper's Monthly, August 1905
Watercolor, oil, and charcoal on illustration board
31¼ × 19½ in. (79.4 × 49.5 cm)
Samuel and Mary Bancroft Memorial Collection, 1935
DAM 1935-45

THE LIBRARY

Elizabeth Shippen Green trained at the Pennsylvania Academy of the Fine Arts, but because the Academy would not instruct students in the mechanics of illustration, she continued her studies with Howard Pyle at the Drexel Institute. Her father, Jasper Green, who had himself been a student at the Academy and an artist–correspondent for *Harper's Weekly* during the Civil War, encouraged her interest in art and introduced her to the technical aspects of illustration.

In a letter of 1906, Green described *The Library* as "a more or less careful portrait of my library at The Red Rose [in] Villa Nova, [Pennsylvania]." It is one of a series of images by Green, depicting the life of a housewife and mother, published under the title "The Mistress of the House" in *Harper's Monthly* magazine in 1905. Green's idyllic vision of a housewife tends to her house plants and garden, does a little mending, studies art in her library, has tea with a caller, reads a picture book with her child, and descends her stairs dressed for dinner.

See detail on page 68

Maxfield Parrish (1870–1966)
Thanksgiving (also known as
The Tramp's Dinner)
Cover for *Collier's Weekly*, November 18, 1905
Oil, charcoal, and pastel on paper on cardboard
20½ × 15½ in. (52.1 × 39.4 cm)
Samuel and Mary R. Bancroft Memorial, 1935
DAM 1935-18

John Sloan (1871–1951)
The Triangle Shirtwaist Factory Fire,
March 1911
Ink and crayon on board
18½ × 14¾ in. (47 × 37.5 cm)
Gift of Helen Farr Sloan, 2000
DAM 2000-762

Maxfield Parrish was raised in Philadelphia and initially trained by his father, artist–engraver Stephen Parrish. The younger Parrish studied illustration with Howard Pyle at the Drexel Institute only briefly before Pyle concluded that there was little else he could teach the twenty-three-year-old artist. By 1904 Parrish was making covers for *Collier's Weekly* regularly, in addition to his work on other periodical and commercial illustrations.

This image, also known as *The Tramp's Dinner*, graced the cover of *Collier's Weekly*'s 1905 Thanksgiving issue, reminding readers that it should take only a sufficiency for one to feel thankful. For the tramp this means a piece of bread, a tin of food, a small fire and a copy of the *New York Times*, all enjoyed under the open sky. In his later illustrations and advertisements, Parrish habitually rendered his backgrounds in a rich blue hue, commonly known as "Parrish blue," which created a look quite different from the pale tones of this work.

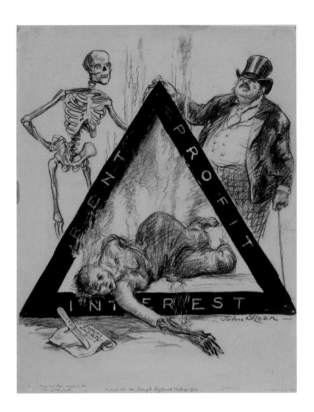

Fire broke out on the eighth floor of the Triangle [Shirt] Waist Company, located on the east side of Washington Square in New York City, late in the afternoon of Saturday, March 25, 1911. One hundred and forty-six employees lost their lives, largely due to the company's inadequate emergency procedures and the city's building laws. Emergency exit doors had been blocked from the outside by the management, and the Fire Department's ladders were only tall enough to reach to the sixth floor, leaving people trapped on the upper floors of the ten-story building. Fire hoses were unable to provide enough pressure for the water to overpower the blaze.

Sloan's memorial image of the tragedy features a dark triangle with the words RENT, INTEREST, and PROFIT lettered on the form. At each side of the figure, Sloan has illustrated his words with a character: PROFIT is a fat tearful businessman whose financial interests have been hit by the fire; INTEREST is represented by a dead young lady, from whose body smoke rises and whose right arm is burnt to the bone; RENT is attended by a posturing skeleton. On the ground below the dead woman, a copy of the Employer's Liability Bill has a knife labeled COURTS plunged into its text.

Charles Dana Gibson (1867–1944)
Suggestion to Bores—Pick out a Young One—She Won't Know How to Escape
Harper's Bazar, September 1913
Ink on illustration board
21¾ × 29 in. (55.2 × 73.7 cm)
Acquisition Fund, 1988
DAM 1988-141

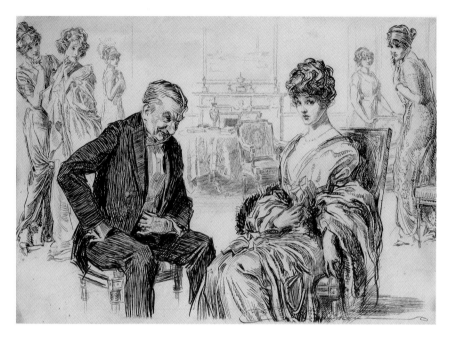

As a young child, Charles Dana Gibson showed a talent for cutting silhouettes and, as a teenager, he entered the Art Students League in New York. During his training at the League, Gibson regularly attempted to sell his sketches to various New York publishers. At the age of nineteen, he sold his work, for the first time, to the weekly magazine *Life* for four dollars; within eighteen months, Gibson was earning as much as thirty dollars for a large cartoon. Following an 1889 to 1890 trip to England, where he met the famous illustrator and cartoonist George du Maurier, and to Paris, where he studied for a short time at the Académie Julian, Gibson created his most famous character, the all-American Gibson Girl.

Suggestion to Bores is a variation of Gibson's perennial favorite subject: courtship and romance between men and women. In this situation there is a disparity of ages. The focus of Gibson's wit, the older Bore, and his young victim sit at the center foreground of the scene, a fashionable salon. The other young women in the room appear to demurely turn away and yet, at the same time, watch the action with fascination. Gibson, a social commentator as well as a humorist, twists the young victim's downward gaze of modesty into a coy, knowing look back out at the viewer.

C. Coles Phillips (1880–1927) ▶
Cover for The Saturday Evening Post,
October 2, 1920
Watercolor, gouache and pencil on illustration board
20 × 16 in. (50.8 × 40.6 cm)
Acquisition Fund, 1988
DAM 1988-79

After limited art-school training that included three months of night classes at the Chase School of Art in New York City, Coles Phillips accepted a position as an advertising-agency sketch artist. In 1906 Phillips opened his own agency. By 1907 he was offering his services as a freelance illustrator. Phillips developed his trademark Fade-away Girl image in 1908, in which some of the foreground and background elements are rendered in the same color, value, or pattern, allowing the girl to blend into the picture and also to be defined by it.

This cover design for *The Saturday Evening Post* is an intriguing play on colors in the range of brown. The tonal unity is accented by small flares of red—in the flower on the chair back, on the young lady's lips, and in the shadow of her cupped sewing hand. The image is a straightforward display of a young lady, dressed to go out, repairing a hem. The interior space is defined simply by an amber-edged, cream-colored panel. Her extremities and the chair's legs extend beyond the edge of the background panel, a technique that serves to concentrate the viewer's focus on her action and form. By silhouetting the lady's legs and the chair's legs against the background, Philips makes a teasing comparison between her well-defined decorative limb and that of the static chair; her fancy skirt and the chair's skirt; her elegantly curved back and the elaborate, but straight, back of the chair.

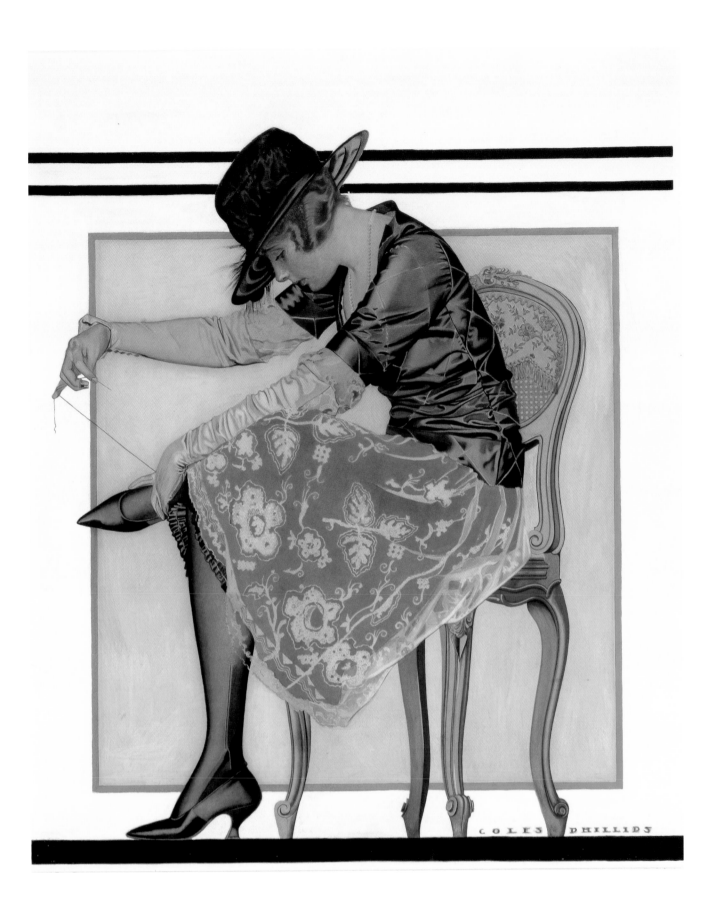

Jessie Willcox Smith (1863–1935)
Back to School Again
Cover for *Good Housekeeping*, October 1928
Watercolor and charcoal on paper
16¼ × 15⅞ in. (41.3 × 40.3 cm)
Louisa du Pont Copeland Memorial Fund, 1971
DAM 1971-7

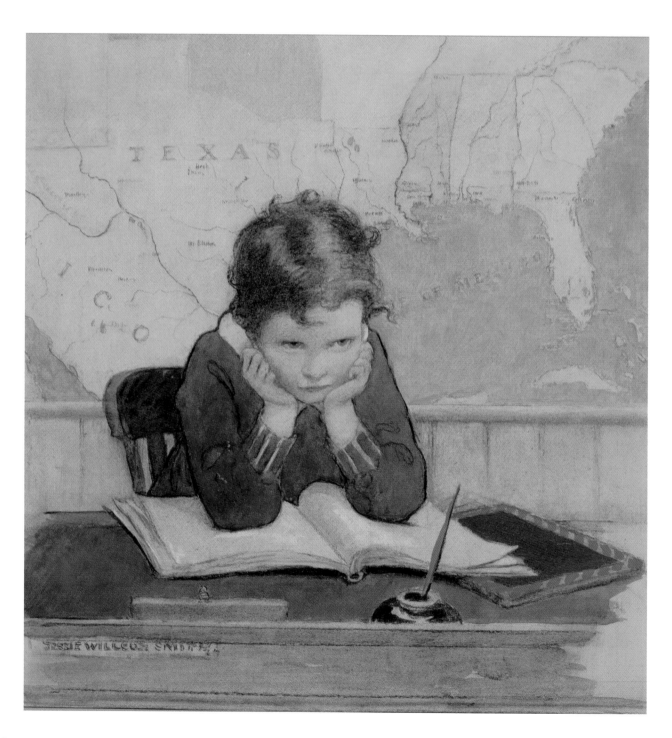

John Held, Jr. (1889–1958)
Then We Went to the Silver Slipper, 1931
For *The Flesh is Weak*, by John Held, Jr.
Ink on illustration board
15 × 10¾ in. (38.1 × 27.3 cm)
Acquisition Fund, 1986
DAM 1986-116

In 1903 Jessie Willcox Smith, already considered one of America's foremost illustrators, was awarded the Mary Smith Prize at the Pennsylvania Academy of the Fine Arts for the best painting by a woman. This was a particularly high accolade for a young woman who had stumbled into the art profession after finding the job of kindergarten teacher unsuitable. Smith began her art studies at the School of Design for Women but quickly moved on to the Academy to study with Thomas Eakins, Thomas Anshutz, and Robert Vonnoh. After her illustration career had already begun, with her first sale to *St. Nicholas* magazine, Smith chose to continue her studies at the Drexel Institute as one of Howard Pyle's first students. Through Pyle's classes, Smith met Violet Oakley and Elizabeth Shippen Green. Pyle nick-named the friends the "Red Rose Girls."

Smith's experience teaching young children provided ample subject matter for her illustrations. In *Back to School Again*, Smith skillfully invokes the wistful daydreams of a child trapped behind a school desk as the world, represented by the map behind her head, carries on outside the classroom.

Held's earliest artistic training came from his father, an engraver–illustrator and popular bandleader. The younger Held sold a cartoon for the first time, at the age of nine, to a local newspaper; he sold his first image to *Life* at fifteen. In 1912 Held moved to New York City, where he initially worked for an advertising company, but soon was selling illustrations regularly to *Vanity Fair*, *Life*, and *Judge*. After a stint in the Navy during World War I, Held returned to New York.

In the 1920s John Held, Jr., created his signature image of the modern woman: the Flapper. In contrast to the earlier, robust Gibson Girl, Held's lady was a skinny, flat-chested vamp with platinum, bobbed hair. In the wake of the Depression and his own financial losses, Held wrote and illustrated a series of books on the state of youth in the 1930s. *Then We Went to the Silver Slipper*, an illustration from his book *The Flesh is Weak*, chronicles the high life of the Jazz-Age thirties. In this scene the help (a waitress or hostess dressed as a fashionable ladies' maid) is as stylish as the gentleman's chic companion—a fact that does not escape his notice.

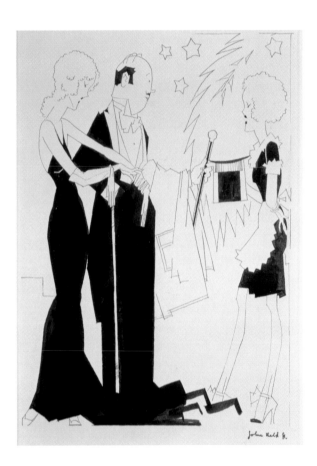

JOHN SLOAN
AND THE EIGHT

As a youth in Lock Haven, Pennsylvania, John Sloan taught himself to etch from a printer's manual. From 1892 until 1904, he worked as an artist at Philadelphia newspapers and contributed illustrations to literary and art magazines. In 1893, frustrated with his classes at the Pennsylvania Academy of the Fine Arts, Sloan founded an informal artists' group, the Charcoal Club, and invited the charismatic artist and teacher Robert Henri to critique the members' work. Henri encouraged the artists to paint "pictures from life," referring to the real world, not an idealized version. In 1904, Sloan moved to New York City, determined to become a painter. He continued to support himself as a commercial artist and, eventually, as a teacher. By 1908, his work had been shown in exhibitions in Philadelphia, Chicago, Pittsburgh, and New York. That year seven other artists joined Sloan to organize their own exhibition at Macbeth Galleries in New York City.

Called "the Eight" by the press, the group included Robert Henri, William Glackens, Ernest Lawson, Everett Shinn, Maurice Prendergast, Arthur B. Davies, and George Luks. They rejected the genteel style and subject matter promoted by the National Academy of Design. The Eight had a spectrum of individual styles; it was their commitment to artistic freedom that unified them. Sloan's paintings centered on his favorite subject: the "drab, shabby, happy, sad, and human life" of a city and its people. The realism of his work, depicting the lively social spirit of the city, was bold and challenging for its time. While Sloan remains best known for the New York scenes he painted during his first ten years there, he was also an able landscapist and portraitist, and a prolific printmaker as well.

The Delaware Art Museum holds the largest collection of Sloan's work, thanks to his widow, Helen Farr Sloan.

Mary F. Holahan
Registrar

Entries by
Joyce K. Schiller
Curator
and
Judith A. Cizek
Curator

Opposite:
John Sloan (1871–1951)
Spring Rain, 1912
Detail from page 87

John Sloan (1871–1951)
Green's Cats, 1899
Oil on canvas
22 × 30 in. (55.9 × 76.2 cm)
Gift of Helen Farr Sloan, 1998
DAM 1998-5

Green's Cats shows a transition in John Sloan's career, revealing influences that carried over from his illustration work into his painting. By 1894 Sloan had developed a poster-like style based upon the bold design, flowing linearity, and flat color patterning of Art Nouveau. Aspects of this style are seen in the two-dimensional quality of the two felines and in the decorative use of the black and white tile pattern of the floor. The painting reflects influences from Sloan's experience as an illustrator—primarily the characteristics of Japanese woodblock prints, which he had studied in preparation to illustrate the story "Sakuma Sukenari: The Story of a Japanese Outlaw" for *Ainslee's Magazine* in 1899. This Oriental influence is clearly evident in the asymmetrical composition, bird's-eye-view perspective, and the way in which the subjects are cut off by the framing edges of the canvas.

Although the overall pictorial effect of *Green's Cats* is decorative, the subject matter is drawn from reality. The playful scene is one Sloan viewed firsthand in Philadelphia at Green's Hotel and Bar, a local gathering place and "watering hole" for the staff of the *Philadelphia Press*, with whom Sloan was employed at the time. Sloan's portrayal of this ordinary scene was influenced by friend and fellow painter Robert Henri, who encouraged the incorporation of subject matter drawn directly from real life.

Green's Cats is a significant work in Sloan's early development as a painter and foreshadows a commitment to the unadorned depiction of the modern world that would subsequently characterize his later work.

John Sloan (1871–1951)
Walnut Street Theater, Philadelphia, 1900
Oil on canvas
25⅛ × 32 in. (63.8 × 81.3 cm)
Gift of Helen Farr Sloan, 1999
DAM 1999-2

In the 1890s John Sloan began to branch out from illustration to explore the nuanced art of painting. He was influenced by the academic style taught at the Pennsylvania Academy of the Fine Arts and by the loose, fluid brushwork used by Robert Henri, whom Sloan met in 1892. Motivated by Henri's instruction, Sloan composed his scenes—depicting everyday life—in the foreground, thus eliminating the softening effect of distance. This combination of subject matter and composition, which Sloan first explored at this time, would become his forte.

Henri's teaching drew upon the work of Edouard Manet and others who were influenced by critic Charles Baudelaire.

Baudelaire, in a critical review of the Paris Salon exhibition of 1845, urged painters to capture the "epic quality from the life of today." Believing the modern American city to be an ideal subject for a modern artist, Sloan created his first series of city-scene paintings, including *Walnut Street Theater*, in Philadelphia between 1896 and 1900. The subject seems hardly heroic. In the dull light of the gas street lamps, theater patrons move across the pavement in front of the dim building and out into the street. The architectural form of the theater is obscured by the throng, the banners and signs that announce the current offering, and the metal armature of the fire escape.

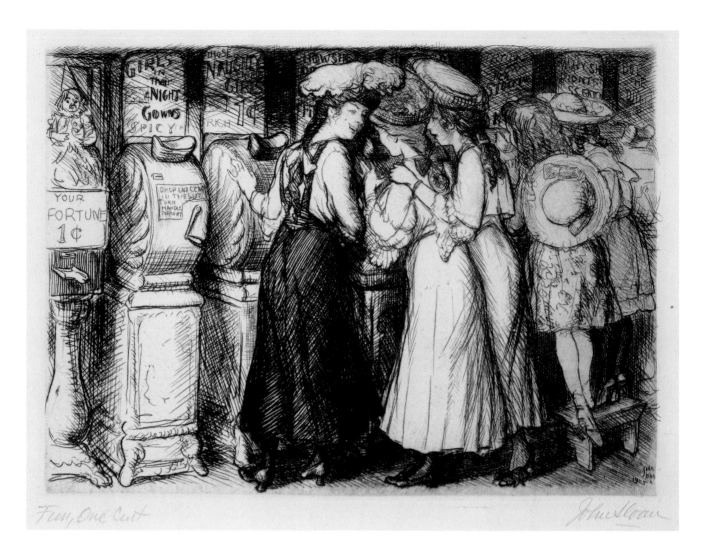

Fun, One Cent

John Sloan

John Sloan (1871–1951)
Fun, One Cent, 1905
From the "New York City Life" series
Etching on paper
5 × 7 in. (12.7 × 17.8 cm)
Gift of Helen Farr Sloan, 1963
DAM 1963-20.66

In the autumn of 1905, John Sloan began a series of etchings entitled "New York City Life" that represents distinct aspects of everyday urban existence. He originally planned a group of ten etchings, but added three more in 1910 and 1911. The series depicts a wide range of classes of people, activities, and conditions: immigrants, popular entertainment, the "art crowd," upper-class society, families, poverty, and prostitution. The scenes reflect the energy and diversity of a city that Sloan saw and experienced firsthand since his arrival from Philadelphia in 1904.

At the turn of the century, New York City underwent enormous changes to accommodate a growing and increasingly diverse population. Shorter work hours and rising wages resulted in an urban population with time and money for leisurely activities. Uptown audiences enjoyed a dazzling nightlife of fashionable restaurants and the Broadway stage; downtown crowds flocked to the cheap amusements offered at carnivals, vaudeville theaters, and nickelodeon arcades. Prior to the advent of moving picture theaters, the nickelodeon, with its hand-cranked moving photographs, was a popular attraction.

In *Fun, One Cent*, Sloan captures the delight of a group of young girls at the nickelodeon arcade on Fourteenth Street near Third Avenue. This work exemplifies Sloan's remarkable ability to capture the robust daily life of the ordinary person. Through this talent, he would establish his reputation as one of the great recorders of city life, and as one of the creators of a uniquely American vision in early twentieth-century art.

John Sloan (1871–1951)
The Women's Page, 1905
From the "New York City Life" series
Steel-faced copper plate etching, ink on paper
4 ⅞ × 6 ¾ in. (12.4 × 17.2 cm)
Gift of Helen Farr Sloan, 1963
DAM 1963-20.68

Following the 1890 publication of documentary photographer Jacob Riis's book, *How the Other Half Lives*, which revealed startling views of New York City's slum life, many artists and writers began to explore the lifestyle of the underclass. John Sloan's "New York City Life" series of etchings specifically explored real-life scenes on Manhattan's lower-west side, where Sloan and his wife, Dolly, lived.

In *The Women's Page*, a lower-class woman, wearing only a slip, sits on a dilapidated rocking chair, reading the fashion page of the newspaper. Sloan accentuates the contrast between the woman and the luxury items she admires by juxtaposing the tall, slender, youthful girl in the newspaper illustration with the "reality" of the stocky woman in the chair. This woman-of-the-house appears to reside in a single room where, simultaneously, a child plays with a cat, laundry soaks in a basin, and a clothesline hangs across a window. Amid her domestic chaos, this working-class woman, absorbed in her paper, is transported to another world. She is so focused that she curls her toes in concentration.

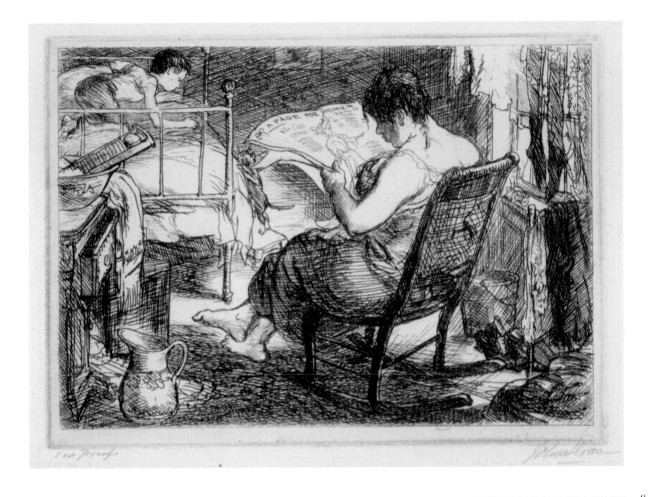

John Sloan (1871–1951)
Iolanthe, 1909
Oil on canvas
32 × 26 in. (81.3 × 66 cm)
Gift of the John Sloan Memorial
Foundation, 1997
DAM 1997·41

Throughout his career John Sloan employed models to sit for him. The model for *Iolanthe*, Yolande Bugbee, posed for the week of November 9, 1909. A few days later, Sloan began this portrait and finished it the following day—a very quick turn-around. The title of the work alludes to Gilbert and Sullivan's operetta of the same name, in which Iolanthe, a fairy billed as "the life and soul of Fairyland," injudiciously marries a mortal, the Lord Chancellor. Iolanthe may have been chosen as a subject because of the character's strong-willed nature and tenuous situation, or Sloan may have painted Yolande as Iolanthe because, as he noted in his journal, she "flitted about" the studio, perhaps reminding him of the character.

Sloan aimed to reveal his models' personalities in their portraits. Yolande's intensity is conveyed by the way she leans forward in her space: although her chin is down, her eyes look up. She holds a folded piece of paper in her hands, in keeping with the artist's dictum of adding "something to the pose that will give it more the look of everyday life." The artist described Yolande as "a very bright, nervous bird-like young lady"— qualities that Sloan also describes effectively on this canvas.

See detail on page 80

John Sloan (1871–1951)
Spring Rain, 1912
Oil on canvas
20¼ × 26¼ in. (51.4 × 66.7 cm)
Gift of the John Sloan Memorial
Foundation, 1986
DAM 1986-107

After working as an illustrator for
the *Philadelphia Inquirer* and the
Philadelphia Press, John Sloan moved to
New York City in 1904. His work in
illustration, which had focused on
human interaction and activities,
provided a background and inspiration
for his important "New York City Life"

etchings of 1905 to 1906, and for the
paintings he produced from 1906
onward, which possess a unique style
of urban realism.

Sloan painted *Spring Rain* to record
the glimpse of a fashionable ankle as
well as the fresh green of a city park
during a spring rain. Its graphic
characteristics—the flattened form of a
female figure, the decorative treatment
of the park benches, and the curvilinear
flow of the tree on the left—are
combined with loose brushwork and an
attention to color harmonies inspired
by the Maratta color theory, which
measured primary and secondary

colors in precise gradations analogous
to musical chords. Sloan had become
acquainted with oil-paint manufacturer
Hardesty Maratta through Robert
Henri in 1909. Sloan later recalled in
his book *Gist of Art*, published in 1939,
that the palette for *Spring Rain* is based
on a Maratta color chord analogous to
a musical seventh, which is translated
into the blue-green, red-purple, orange,
and yellow-green colors that appear in
the trees to the right; the building in
the background; the noted ankle; and
the flower bed, trees, and grass on the
left of the composition.

John Sloan (1871–1951)
Autumn Rocks and Bushes, 1914
Oil on canvas
19 ¹⁵/₁₆ × 23 ¹⁵/₁₆ in. (50.6 × 60.8 cm)
Gift of the John Sloan Trust, 1996
DAM 1996-407

At the suggestion of Robert Henri, John Sloan and his wife, Dolly, visited the artists' colony of Gloucester, Massachusetts in the summer of 1914. Each summer thereafter, through 1918, they rented a cottage in East Gloucester where they were joined by other artists such as Charles Allan, Alice Beach Winter, Stuart Davis, Davis's mother, Helen, and brother Wyatt, a sculptor. The rocks, bushes, moors, docks, and sea of the region provided the "Red Cottage" artists with a variety of landscape motifs, which they could paint directly from nature in an atmosphere of artistic freedom.

Relieved of his duties as an illustrator and instructor in New York City, Sloan was able to concentrate exclusively on painting in Gloucester. He produced sixty-four paintings in 1914, primarily landscapes, including *Autumn Rocks and Bushes*. The painting, which features spontaneous, bold brushwork and intense color, shows a degree of experimentation and free expression less evident in his New York City narrative work. The absence of figures and the dynamic energy are so uncharacteristic of Sloan that this work suggests a new inspiration. Sloan's bold color palette came from his association with Hardesty Maratta, an oil-paint manufacturer. Maratta's prescribed palettes enabled Sloan to develop a unique color orchestration for each work.

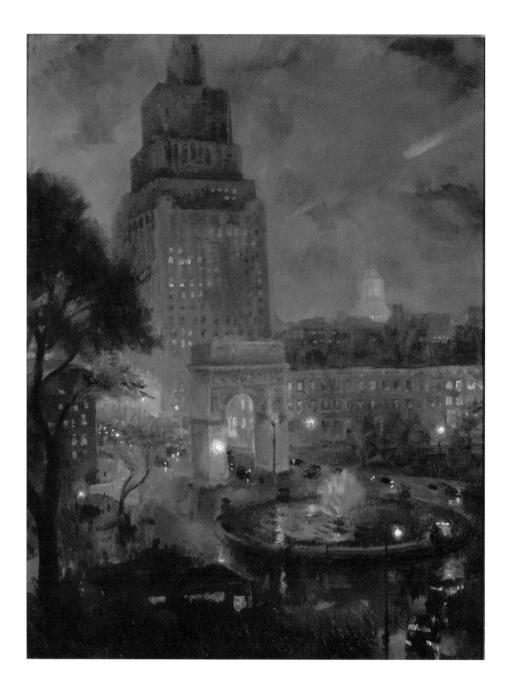

John Sloan (1871–1951)
Wet Night, Washington Square,
1928
Oil on panel
26 × 20 in. (66 × 50.8 cm)
Gift of the John Sloan Memorial
Foundation, 1997
DAM 1997-38

In early February 1927, John Sloan moved to a studio on Washington Square in Greenwich Village. During this time Sloan focused his attention on experimenting with a painting technique—a system of under-painting and glazing—that would allow the maximal use of color and impart a solidity of form within a composition of limited spatial depth. Although his studio overlooked one of the great architectural attractions of New York City, portraits and nudes in the studio were the primary motifs for these explorations.

Sloan produced very few paintings on the subject of the city scene during this period, but Washington Square served as the backdrop for two paintings of monumental nudes and became the primary subject of four known paintings, including *Wet Night, Washington Square*. In this nightscape, Sloan portrays the park, fountain, and arch against the backdrop of looming skyscraper and sky, capturing the reflections of the city's electrical lights on the Square's rain-wet surfaces.

John Sloan (1871–1951)
Procession to the Cross of the Martyrs, 1930
Tempera and oil varnish glaze on panel
24 × 32 in. (61 × 81.3 cm)
Gift of the John Sloan Memorial Foundation, 1997
DAM 1997-48

In 1919, at the suggestion of Robert Henri, John Sloan ceased spending summers at the artists' colony in Gloucester, Massachusetts, in favor of the inexpensive and less-populated Southwest. Sloan eventually designed a house six miles northwest of Santa Fe, New Mexico, that he named *Sinagua*, the Spanish term for "without water." Built on a hill, from which Sloan could view the bright colors, flat sunlit forms, and barren enormity of the Southwestern terrain, Sinagua relied on cisterns to catch water during the infrequent rains. Santa Fe and its environs stimulated Sloan to produce numerous paintings, drawings, and prints of the landscape and the customs and rituals of the local people.

Procession to the Cross of the Martyrs is Sloan's representation of a candlelight pilgrimage to the monument, which was erected to commemorate the twenty-one Franciscan friars killed in the 1680 Pueblo Indian Revolt. Held on the final evening of Fiesta Week in Santa Fe every September, the procession attracts large crowds from Santa Fe and a multitude of tourists. The focus of the scene, set high on a hill overlooking the town, is the white stone cross, backed by a brilliant, aqua-blue night sky that is traversed by a slivered moon, clouds, and ascending smoke. The intense gold and orange glow of the candles and fireplaces that line the winding path, in bold contrast to the luminous night sky, lends a mystical and spiritual quality to the painting.

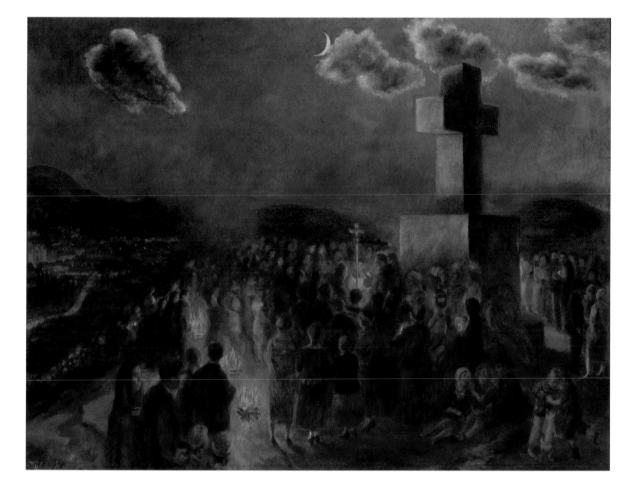

Everett Shinn (1876–1953)
Backstage Scene, 1900
Watercolor on paper mounted on board
8½ × 13⅜ in. (21.6 × 34 cm)
Special Purchase Fund, 1966
DAM 1966-78

After studying mechanical drawing at Spring Gardens Institute in Philadelphia, Everett Shinn enrolled at the Pennsylvania Academy of the Fine Arts. Like many of his contemporaries, Shinn worked as an artist-reporter for the *Philadelphia Press* concurrently with his studies. In 1897 Shinn moved to New York City, where he initially worked as a staff artist for the *New York World* and as a freelance illustrator for other publications. By 1900 Shinn was painting in oils and exhibiting his pastels and drawings of New York City scenes.

Shinn had long been interested in theater production, and theatrical subject matter began to dominate his work in 1900. Most of his work on this subject depicts the scene on stage or the relationship between the stage action and the audience. *Backstage Scene* is unusual in that it discloses the action behind the public face of the stage. The proscenium curtain, left of center, reveals a scenery change. By taking us into the working heart of the theater, Shinn exposes its illusory quality and challenges our ability to distinguish real action from fantasy.

Ernest Lawson (1873–1939)
Washington Bridge, New York City, c.1915–1925
Oil on canvas
25 ½ × 29 ½ in. (64.8 × 74.9 cm)
Gift of the Friends of Art, 1964
DAM 1964-2

Canadian-born Ernest Lawson worked for a textile designer and studied at the Kansas City Art Institute. After a stint working as a draftsman in Mexico City, Lawson moved to New York City and continued his studies with American Impressionist painters John Henry Twachtman and J. Alden Weir at the Art Students League of New York. Later he studied at the Académie Julian in Paris and had the opportunity to meet famed French Impressionist Alfred Sisley.

By 1898 Lawson had settled in Washington Heights, at the northern tip of Manhattan, a locale that provided his primary subject matter for the next fifteen years. Lawson produced countless images of the Harlem River and local bridges, including *Washington Bridge, New York City*. Although Lawson exhibited as a member of the Eight, both his subject matter and technique with paint visually ally him with both the American Impressionists and Realists. What is distinctive about Lawson's images is his boldly applied, thick paint, layered in a variegated meld of color—an effect that caused one critic to dub him, "Lawson of the Crushed Jewels."

Robert Henri (1865–1929)
Little Girl of the Southwest, 1917
Oil on canvas
20 × 24 in. (50.8 × 61 cm)
Special Purchase Fund, 1920
DAM 1920-1

Although best known as a founding member of the Eight and an Urban Realist painter, Robert Henri was also an avid portraitist. Born Robert Henry Cozad in Cincinnati, Ohio, Henri attended the Pennsylvania Academy of the Fine Arts in Philadelphia and the Académie Julian in Paris. He first turned to portraits in the late 1890s, giving his attention to commissioned full-length subjects as well as more intimate portraits of family and friends. His earliest portraits were painted in dark tonalities, reminiscent of Velázquez, Hals, and Manet, and focused on compositional mass and anatomical solidity, but his approach changed as his interests evolved.

Variety of location and subject was important to Henri's development in portrait painting. On his travels in the United States and abroad, Henri sought subjects whose appearance and character revealed a deeper truth to him. Henri visited Santa Fe in the summer of 1916, at the suggestion of ethnologist Edgar L. Hewitt, and returned the following summer, fascinated by the Hispanic and Native American people, and the dazzling color and light he found in the region. *Little Girl of the Southwest* depicts a shy, dark-haired girl of probable Mexican American descent. Rendered in loose brush strokes and a bright color palette, the girl is set against a background that suggests adobe and other local decorative materials. Through his highly personal approach—an intention to capture what he called the "dignity of life" of his subject—Henri creates an exuberant portrait of ethnic beauty and childhood innocence.

George Luks (1867–1933)
Trout Fishing, 1919
Oil on canvas
25 × 30 in. (63.5 × 76.2 cm)
Gift of Mrs. Alfred E. Bissell, 1963
DAM 1963-35

George Luks was born in the central-Pennsylvania logging town of Williamsport, to well-educated, professional parents who supported his early interest in art and imparted a respect for the common man. In 1894 Luks joined the staff of illustrators at the *Philadelphia Press*, where he met John Sloan, William Glackens, and Everett Shinn. He gathered with his colleagues at the studio of Robert Henri, and responded to the group's encouragement to paint scenes of common, everyday city life with his own oil and watercolor paintings of subject matter drawn from the streets.

Although Luks is best known as a New York City street painter and member of the Eight, he also had an interest in landscape painting, which he cultivated during summer trips throughout the region. At the invitation of Ernest Lawson, Luks joined a fishing trip to Nova Scotia in 1919. During this outing he executed a series of paintings that included *Trout Fishing*. The intensely colored, dramatic scene depicts a fisherman, with upraised rod, standing on a large fallen tree that rests on rocks in a fast-moving stream. The theme of man against nature is seen in the diminutive figure of the fisherman attempting to hook his prize from the raging river. Swiftly moving water is depicted by boldly brushed swirls of dark blue and purple, while thick blots of green and yellow pigment suggest moss and lichens on the fallen tree. Luks, once called a "swashbuckler of the brush," applied paint rapidly to express the spontaneity of the scene.

AMERICAN ART OF THE EARLY TWENTIETH CENTURY

I n the early decades of the twentieth century, many artists focused on subject matter drawn from the everyday life of common people. New York City attracted numerous artists who chose to paint the changing neighborhoods and growing lower and middle classes at work and at play. In the first two decades of the century, the work of John Sloan and the Eight, which included such subject matter, prompted an outraged critic to dub the group the "Ash Can School." The group's work formed a uniquely American vision that had a profound effect on subsequent art movements, particularly American Scene painting of the 1930s and 1940s, exemplified by the work of Reginald Marsh and Edward Hopper; the Regionalist movement; and American Realism, typified in the works of N. C. Wyeth, Andrew Wyeth, and later, James Browning Wyeth.

In the first half of the century, personal artistic styles varied from forms of realism to stylistic approaches influenced by modernist European trends brought to the United States by an influx of artist immigrants in the era of World War I. Alfred Stieglitz's New York City gallery, 291, featured small exhibitions of European Modernist work, which had a significant impact on American artists such as Marsden Hartley. In 1913 the International Exhibition of Modern Art, better known as the Armory Show, traveled to New York City, Chicago, and Boston, affording American artists exposure to the artistic trends of the European avant-garde: Post-Impressionism, Cubism, Expressionism, and Futurism.

Many artists viewed painting, not as imitation but rather as an act of intuition, formal exploration, or both. Responding to their inner visions, artists created new styles that were frequently abstract. Although inspired by representational subject matter, compositions were often reduced to the basic elements of color, line, and shape. Abstract idioms, expressing the artist's personal reactions to the world or simply formal re-conceptions, became more important than the accurate depiction of a scene. In the 1920s, 1930s, and 1940s, many artists, such as William Zorach, John Graham, Hans Hofmann, Jacob Lawrence, and Arshile Gorky, adopted the styles of Cubism, Surrealism, and Non-Objective art introduced by artist immigrants escaping the political turmoil that surrounded the advent of World War II in Europe.

Judith A. Cizek
Curator

Opposite:
Jacob Lawrence (1917–2000)
Bar and Grill, 1941
Detail from page 108

Marsden Hartley (1877–1943)
Landscape, New Mexico, 1922–1923
Oil on canvas
19 ¾ × 28 ⅞ in. (50.2 × 73.3 cm)
Special Purchase Fund, 1958
DAM 1958-15

Marsden Hartley, who was a close associate of photographer, editor and art dealer Alfred Stieglitz in New York City, is considered one of the preeminent American Modernist painters of the early twentieth century. Influenced by the avant-garde work of artists Paul Cézanne, Henri Matisse, and Pablo Picasso, which he viewed firsthand at exhibitions at Stieglitz's

291 gallery, Hartley developed a style of painting based on liberated color, fragmented form, and bold brushwork. Inspired by the transcendental writing of Ralph Waldo Emerson, Henry David Thoreau, and Walt Whitman, Hartley believed that art should convey the artist's mood and emotional response to nature.

While visiting Berlin in 1922, Hartley began a series of landscapes entitled "New Mexico Recollections," which includes *Landscape, New Mexico*. He based the series on reminiscences of the southwestern landscape he had observed in Taos and Santa Fe, New Mexico, in 1918 and 1919.

In a powerful evocation of the place, Hartley depicts a vision of nature that lies halfway between the imagined and the remembered. Filled with barren hills, twisted clouds, and bulbous earth and tree forms, the work is painted in dark tonalities with heavy outlines that emphasize the volume and imposing presence of southwestern canyons, hills, and rock formations. Through the mass and undulating motion of the forms, the painting depicts the striking landscape of the American West—as filtered through the mood and emotion of the artist.

William Zorach (1887–1966)
Head of Dahlov, 1922–1923
White marble
14¾ × 11⅝ × 11 in. (37.5 × 29.5 × 27.9 cm)
Bequest of Mrs. Robert Wheelwright, 1969
DAM 1969-2

William Zorach, a leader of the Modernist movement in the United States, is considered one of America's great twentieth-century sculptors. Raised in Cleveland, Ohio, he studied art first at the Cleveland School of Art, and later at the National Academy of Art in New York City. In 1910 he traveled to Paris and observed the work of the French Fauves and Cubists, which influenced him to take a more abstract approach to his painting. He continued his exploration of avant-garde artistic theories upon his return to the United States in 1912. His work was selected for the important Armory Show of 1913. He began sculpting in 1917 and, by 1922, decided to devote himself to that medium. Working in wood and stone, Zorach became an advocate of direct carving, rather than the traditional method of preparing models in clay to be transferred into stone by professional carvers.

William Zorach's sculptures are characterized by simplified, massive form and traditional subject matter: animals, children, and the interaction between mother and child. His daughter, Dahlov, served as the subject of this sculpture, as well as in much of his other work. Although Zorach conveys little-girl innocence through softly rounded, abstract features, he also preserves the texture, weight, and—to some extent—shape of the block of marble from which the sculpture is carved. Despite its intimately charming and family-oriented subject matter, *Head of Dahlov* embodies the strength and density of its raw material of origin.

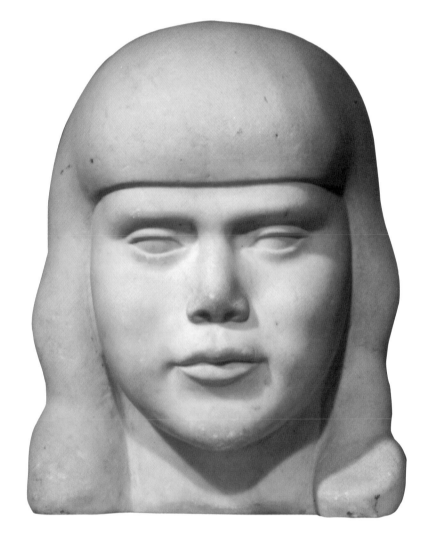

Charles Burchfield (1893–1967)
March, 1923–1928
Watercolor and pencil on paper
30 × 43 in. (76.2 × 109.2 cm)
Bequest of John L. Sexton, 1955
DAM 1955-19

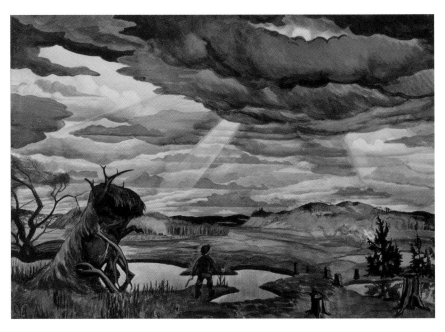

One of the preeminent American Scene painters of the twentieth century, Charles Burchfield captured the nuances of small town streets, industrial cities, and the rolling hills of northern Ohio and western New York in a style known as Romantic Realism. He is noted for his mystical landscapes, which embody his emotionally charged interpretations of the forces of nature. Born in Ashtabula Harbor, Ohio, Burchfield settled in Buffalo, New York, in 1921 as a wallpaper designer. By the early 1920s the responsibilities of a family and full-time job prompted Burchfield to return to landscape painting, a passion he had indulged in his earlier work in Ohio, and he explored the terrain around the suburb of Gardenville, New York, seeking subject matter through which he could express his feelings about nature, life, and the cosmos.

March, a large-scale watercolor painted between 1923 and 1928, exhibits Burchfield's interest in the seasonal moods of nature. In his journal, the artist reveals his affection for the season of spring in his wish to be "the embodiment of March—both in life and art." Burchfield describes March as "the month of uncouthness, of raw ungoverned power...an awkward youth just emerging from boyhood." Through an evocative and stylistically unique pictorial language that bridges realism and abstraction, Burchfield creates a scene of life emerging from the cold darkness of winter and symbolically expresses the concepts of spiritual rebirth, physical rejuvenation, and hope.

Paul Manship (1885–1966)
Europa and the Bull, 1924
Bronze
10½ × 12⅞ × 7½ in. (26.7 × 32.7 × 19.1 cm)
Gift of Titus C. Geesey, 1966
DAM 1966-92

Paul Manship, whose work bridged the traditional and modern, was an outstanding American sculptor of the early twentieth century. His initial desire to pursue sculpture was largely motivated by his colorblindness, which precluded a painting career. Originally from St. Paul, Minnesota, Manship first studied at the Art Students League in New York City, then apprenticed under sculptor Solom Borglum, and later studied with Charles Grafly at the Pennsylvania Academy of the Fine Arts. At age twenty-four, he won the American Prix de Rome, which allowed him to study in Rome and to travel in Greece. There, Manship observed the simplified naturalism of archaic Greek art and mythology, which informed his work throughout his career. Like other modern artists, Manship used the art of the past as a springboard for creating a new aesthetic, free of the conventions that bound his more traditional contemporaries.

This sculpture, on the classical theme of Europa and the Bull, was one of twenty cast in 1924. The work demonstrates Manship's turn from earlier decorative and linear styles toward compositions in closed, solid form. Inspired by the myth of Zeus

transforming himself into an animal to seduce mortal maidens, this piece is composed of swelling forms and repetitive curves that flow with movement. This fluidity underscores the sensuality of the amorous subject. Seduced by the bull's power and beauty, the young maiden gently caresses the animal, demonstrating rapport between beast and human—a common theme in Manship's work.

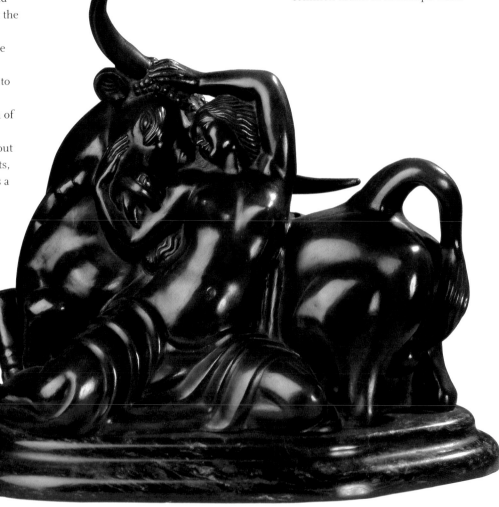

John D. Graham (1881–1961)
Still Life—Pitcher and Fruit, 1926
Oil on canvas
15 ½ × 19 ⅜ in. (39.4 × 49.2 cm)
Gift of Helen Farr Sloan, 1975
DAM 1975-39

Born Ivan Dabrowsky in Kiev, Russia, John Graham was influenced by European Post-Impressionist and Modernist painters Paul Cézanne, Pablo Picasso, and Georges Braque. During the 1917 Russian Revolution, Graham moved first to Paris and then to New York City, where he studied with John Sloan at the Art Students League of New York. A major figure in American avant-garde circles of the late 1920s and 1930s, Graham influenced and befriended a younger generation of artists such as David Smith, Arshile Gorky, Willem de Kooning, and Jackson Pollock. Graham's 1926 *Still Life—Pitcher and Fruit* was part of John Sloan's personal collection, and may have been a gift from Graham to his teacher.

In this painting, Graham uses an arrangement of fruit and dishes as a starting point for exploring the formal relationships of shapes, colors, and lines. After scrutinizing the objects in front of him, he reduced the forms into a grouping of flat shapes that echo the flatness of the picture plane. Graham tilts the tabletop, plate, and lip of the pitcher toward the viewer, creating an incongruous spatial perspective. He depicts the fruit as flattened abstract shapes, and further compresses the space with the shallow placement of the back wall. The playing card of diamond suit, cut off by the edge of the canvas, adds a familiar element of reality to the carefully constructed, abstract composition.

Reginald Marsh (1898–1954)
Atlantic City Beach, 1931
Tempera on canvas mounted on panel
36 × 60 in. (91.4 × 152.4 cm)
Bequest of Mrs. Reginald Marsh, 1979
DAM 1979-48

Reginald Marsh was born in Paris to American parents who were both artists. The family moved back to the United States, and Marsh attended Yale University. After graduation, Marsh settled in New York City to work as a freelance illustrator and cartoonist. Attending the Art Students League of New York in his spare time, Marsh came into contact with Kenneth Hayes Miller, John Sloan, and George Luks, whose images of contemporary urban life were profoundly influential. He focused on painting and became one of the preeminent Social Realist artists of the 1930s. Drawn to the mundane activities and leisure pursuits of the city's lower and middle classes during the Depression, Marsh found inspiration in subways, bread lines, dance marathons, burlesque entertainments, carnival sideshows, and Bowery bums. A motif to which he returned often was the public beach.

This painting of the beach on a hot summer day is replete with bathing beauties and masses of people, set against the backdrop of the sea and open air. The grouping of interlocking and weaving bodies shows Marsh's admiration for art of the past, particularly the compositions of Michelangelo and Rubens. Nonetheless, this work, with its allusions to the unadorned aspects of life, clearly depicts the present. Less-than-perfect human anatomies inhabit the scene, along with references to popular beach accessories of the 1930s: bathing caps, swim goggles, sand pail, and ukulele. By cutting off the composition at all sides, Marsh gives the scene a snapshot quality, and enhances the effect of a crowd, in the continuous motion of various activities.

Hans Hofmann (1880–1966)
Still Life—Fruit Bowl, 1941
Casein on plywood
34 × 24 in. (86.4 × 61 cm)
Special Purchase Fund, 1971
DAM 1971-173

Born in Weissenburg, Germany in 1880, Hans Hofmann was the only artist of the New York School of Painting to participate directly in the European Modernist movement of the first two decades of the twentieth century. Hofmann studied in Paris and participated in exhibitions in Berlin, where he witnessed Cubism, Fauvism, Futurism, and German Expressionism originate and flourish. This exposure influenced his exploration of color and spatial relationships in his art, and became the basis of his teaching—first at his school in Munich, which he opened in 1915, and later at a school he founded in New York City in 1934. His artistic theories, work, and instruction had a great impact on the evolution of American art, particularly Abstract Expressionism, from the 1930s until his death in 1966.

The lively and exuberant palette of *Still Life—Fruit Bowl*, reminiscent of the Fauvist work of Henri Matisse, is typical of the numerous works that Hofmann painted in his New York City studio in the 1930s and 1940s. Showing little concern for the representational portrayal of objects, Hofmann simplifies the bowl, dish, and fruit, situated on a tilted tabletop, into flat, curvilinear and geometric shapes painted with translucent hues of blue, red, and yellow, and their complementary colors. The abstract shapes and the juxtaposition of vibrant colors cause the forms to seem to vibrate and oscillate in the narrow space, creating the illusion of spatial depth. Hofmann referred to the play of intense color relationships, and the tensions created by the flatness of the picture plane and the illusionistic depth of the composition as a "push and pull" effect.

Jacob Lawrence (1917–2000)
Bar and Grill, 1941
Gouache on paper
16¾ × 22¾ in. (42.5 × 57.8 cm)
Gift of the National Academy of Design,
Henry Ward Ranger Fund, 1975
DAM 1975-90

Jacob Lawrence, a child of the Depression, attended public school in New York City's Harlem and studied art after school with painter-sculptor Charles Alston. Lawrence formed his decision to pursue painting as a career early in life, against the backdrop of a great surge of African American culture in the 1920s and 1930s. Known as the "Harlem Renaissance," this environment of visual arts and literature emphasized a strong social awareness and Black consciousness. In Harlem Lawrence came into contact with some of the leading intellectuals and artists of the day, most notably Romare Bearden, Augusta Savage, Langston Hughes, and W. E. B. Du Bois. Lawrence's paintings operate as thematic narratives drawn from historic African American experiences, oral traditions, and contemporary life.

In *Bar and Grill*, Lawrence portrays explicitly the racial prejudice he experienced in a segregated New Orleans bar he visited in 1941. The painting is rendered in bold, sharp colors, which Lawrence attributed to his fascination with the color patterns of the inexpensive throw rugs that brightened the poor homes of Harlem. A striking feature of the work is the composition of strong diagonal lines and overlapping planes in an essentially flat pictorial space—a style Lawrence termed "dynamic Cubism." Perspective is skewed so that everything in the scene is thrust forward. Figures and objects are distorted, reduced to outlines and angular shapes. Lawrence's placement of the strong vertical form of the wall at the center of the composition underscores the imposed separation between the black and white patrons.

See detail on page 98

Arshile Gorky (1904–1948)
Untitled, 1943
Wax crayon and pencil on paper
14¾ × 23⅜ in. (37.5 × 59.4 cm)
Gift of anonymous donor, 1988
DAM 1988-144

Born Vosdanig Manoog Adoian in rural Turkish Armenia, Arshile Gorky was forced to flee his country as a teenager during World War I due to a massive extermination campaign against the Armenians by the Turks. First immigrating to Russia, and later to the United States, Gorky set his sights on a professional career as an artist. Although the fragmented forms and geometric compositions of Cubism were an inspiration in his early work, the irregular biomorphic shapes and spontaneous use of line of Surrealism became a major influence in his work

by the 1930s. It was not until the early 1940s, however, that Gorky found a unique artistic voice.

In 1943 Gorky, his wife, Agnes, and their newborn daughter visited Agnes's father's estate, Crooked Run Farm, in Hamilton, Virginia. Here, taking delight in his natural surroundings by working outdoors, Gorky produced some of the most original and sophisticated drawings of his career, including *Untitled*. In this work, Gorky makes reference to the life he saw "in the grass." The piece has a mysterious power, expressed through its fluid

lines, out of which metaphoric images emerge. Contours of interlocking shapes bulge and contract like soft organisms, reproductive organs, and rare botanical forms. Horizontal and vertical punctuations of colored crayon intersperse the masterfully controlled but free-flowing lines, rhythmically moving the viewer in and out of the work's shallow space. Rather than realistically rendering examples of the fertility and abundance of his environment, Gorky creates an overall visual metaphor for the pulsating, living world of nature.

Edward Hopper (1882–1967)
Summertime, 1943
Oil on canvas
29⅛ × 44 in. (74 × 111.8 cm)
Gift of Dora Sexton Brown, 1962
DAM 1962-28

A superlative American Scene painter of the 1930s and 1940s, Edward Hopper infused his landscapes and cityscapes with a disturbing outlook, representing the modern world as a lonely, alienating place. Born in Nyack, New York, he showed an early inclination towards the visual arts and later attended the New York School of Illustrating and the New York School of Art. He studied with Robert Henri, who compelled him to focus his artistic efforts on subjects found in everyday city life. Hopper's interior and exterior settings, inhabited by a solitary figure or a group of non-communicating individuals, capture the atmosphere of urban life in a style that uniquely blends realism with abstraction.

Summertime conveys the feeling of a sweltering day in New York City. The curtain in the window, apparently set in motion by an interior fan, emphasizes the stillness of the air outside. The strong vertical and horizontal design of the building and sidewalk suggests a scene that extends beyond the canvas. A lone female figure in a clinging dress—based on drawings of the artist's wife, Jo—creates a counterpoint to the almost abstract starkness of the background architecture and the austere patterns of light and shadow. Hopper manipulates the seemingly straightforward scene to convey a mood of eerie loneliness within the formally balanced and impersonal city block. Close inspection reveals that the woman's eyes lack pupils, and that her shadow responds incorrectly to the light. Devoid of any specific narrative, the scene projects the vast emptiness of modern urban existence.

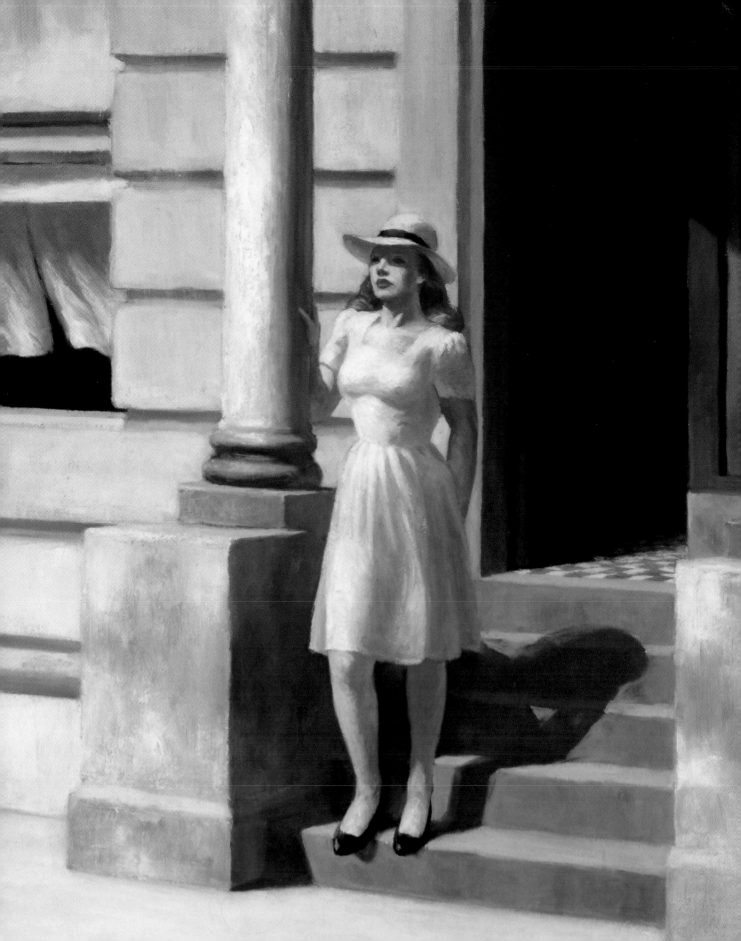

N. C. [Newell Convers] Wyeth
(1882–1945)
The Springhouse, 1944
Tempera on board
36 × 48 in. (91.4 × 121.9 cm)
Special Purchase Fund, 1946
DAM 1946-1

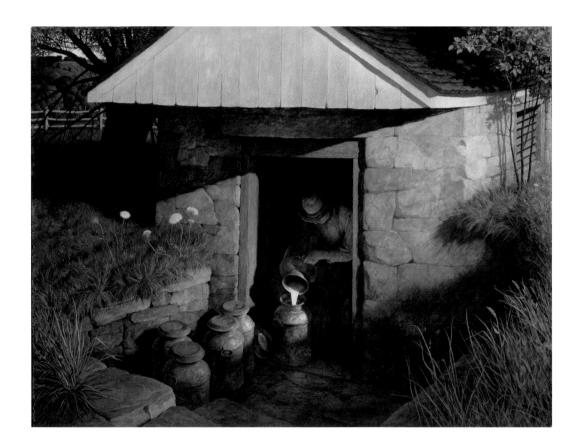

Known first as an illustrator, N. C. Wyeth also established a reputation as a foremost American Regionalist painter of the 1930s and 1940s through his paintings devoted to the life and landscape around his home and studio in Chadds Ford, Pennsylvania. Raised in Neeham, Massachusetts, Wyeth enrolled in the Howard Pyle School of Art in Wilmington, Delaware, in 1902, and attended summer sessions in Chadds Ford, where he was encouraged to work outdoors, compose from his imagination, and develop an acute attention to detail. In 1907, he settled in Chadds Ford permanently. While earning a living as an illustrator, Wyeth often spent much of his free time painting landscapes and genre scenes that celebrated the local countryside and lifestyle.

As art historian Elizabeth Hawkes has pointed out in her writing, *Springhouse* is a composite image of the typical stone structures of Chadds Ford and Wyeth's childhood memories of farm life. In this scene, a farmer pours milk into a can to be taken to the creamery. Against the darkness of the interior of the storage springhouse, the early morning sunlight illuminates the white milk. The grasses, Queen Anne's lace, the leaves of the tree, and the mottled texture of the stone wall are finely articulated. In this painting, Wyeth presents a romantic and nostalgic view of an activity, which was commonplace two decades earlier, but was being replaced by the modern invention of refrigeration.

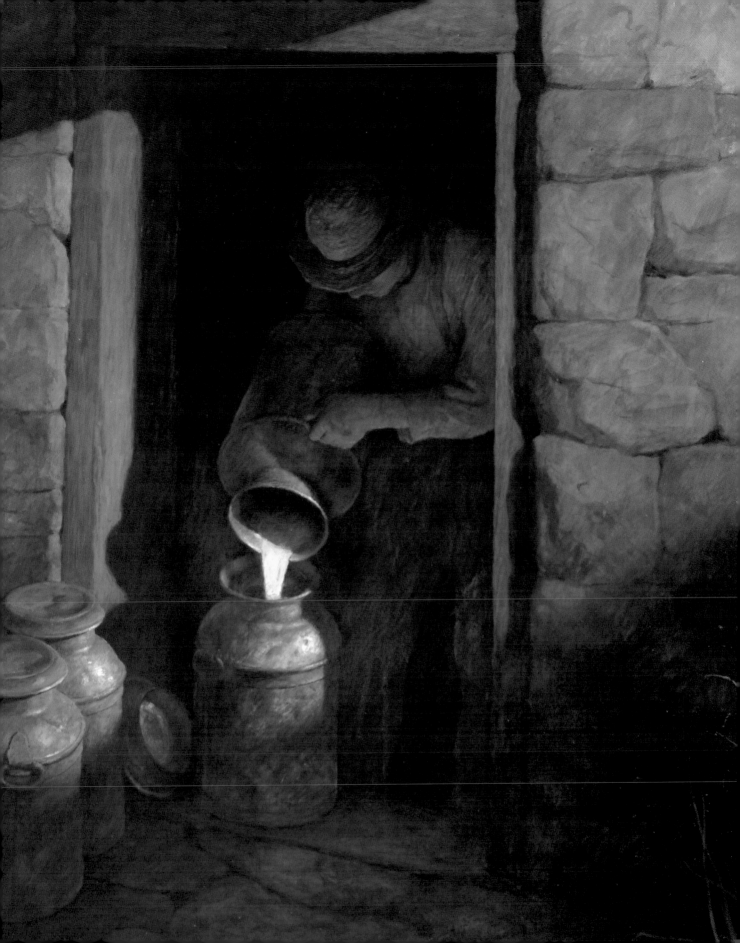

POST–WORLD WAR II AMERICAN ART

Many American artists in the 1940s emulated the abstract approach of the European Modernist trends—the fragmented forms of Cubism, geometric compositions of Non-Objective art, and the subconscious directives of Surrealism—brought to America by European artist immigrants escaping the turmoil surrounding World War II. The Abstract Expressionist movement in America, exemplified by the work of Robert Motherwell and Mark Tobey, grew out of this influx of aesthetic influences in the 1940s and 1950s.

After the mid-century, a number of artists rejected the introspective basis of Abstract Expressionism and explored painting and sculpture in minimally abstract and Non-Objective styles, as seen in the work of Louise Nevelson and Al Held. The Pop Art movement that emerged in the 1960s sought to incorporate actual objects of contemporary American popular culture into painting and sculpture, thus blurring the boundaries between art and life. The found-object paintings of Jim Dine, the American-sign style of Robert Indiana, and the tableaux of George Segal demonstrate the varied approaches, wide range of materials, and personal visions that informed Pop Art. The later, equine sculpture of Deborah Butterfield, constructed of such materials as steel beams and the discarded letters of a theater sign, shows indebtedness to the found-object aesthetic.

Art created in the latter decades of the twentieth century reflects radical changes in not only the world of art but also in Western culture in general. Among these changes is the recognition of a richly pluralistic American society. Thus, new styles in painting, sculpture, and other media have arisen, many incorporating nontraditional materials and new art forms. Much of this work addresses broad contemporary concerns related to gender, as in the work of Grace Hartigan; race and ethnic background, exemplified in the paintings of Robert Colescott and the quilts of Elizabeth Talford Scott; as well as social politics and a quest for self-identity in a complex world.

Judith A. Cizek
Curator

Opposite:
Mark Tobey (1890–1976)
Geography of Phantasy, 1948
Detail from page 116

See detail on page 114

Mark Tobey (1890–1976)
Geography of Phantasy, 1948
Tempera on paper
20 × 26 in. (50.8 × 66 cm)
Acquired through the Gift of Helen Farr
Sloan, 1999
DAM 1999-4

Influenced by the Bahai'i World Faith early in his career, Mark Tobey sought to express the idea of a divine reality that is a vital, moving, and progressive force. A move to Seattle, Washington, in 1922, and a trip to China and Japan in 1934 exposed Tobey to a wealth of East Asian culture and art. Tobey was struck by the delicate yet expressive brushwork of Zen masters, who created a wide range of feeling and expression within the limitations of a pictographic form of writing. This influence, in combination with the abstract form—flattened space and liberated color drawn from European avant-garde sources—became the basis of Tobey's unique pictorial language and artistic vision.

Tobey's paintings unfold slowly and reveal their "secrets" only after careful scrutiny, in a manner similar to Japanese *shibui*, a kind of hidden beauty that discloses itself slowly over time. The title *Geography of Phantasy* is vague, evocative, and poetic, suggesting a realm of personal thought and imagination. The small-scale, intimate format of this work, created in tempera to allow for a meticulous handling of paint, draws the spectator through an intricate network of calligraphic lines and underlying strokes of color. As the movement of the lines lead the viewer around the interior space of the painting, abstract symbols, anthropomorphic references, and regions of color are slowly disclosed, along with the true spatial depth of the work, which at first appears flat. The painting is replete with pauses and flourishes, akin to the themes and variations of a musical composition.

Robert Motherwell (1915–1991)
Je t'aime No. VIII (Mallarmé's Swan: Homage), 1957
Oil on linen
42 × 40 in. (106.7 × 101.6 cm)
F. V. du Pont Acquisition Fund and Partial Gift of the Dedalus Foundation, 1998
DAM 1998-192

Robert Motherwell, one of the founders of the Abstract Expressionist movement that emerged in New York City in the late 1940s and early 1950s, was inspired by European Modernists such as Picasso, Matisse, Mondrian, and Miró. His work was also influenced by French Symbolist poetry, as exemplified in the work of Baudelaire, Rimbaud, and Mallarmé, and by Surrealism. In the early 1940s, Motherwell made direct contact with Roberto Matta and other Surrealist artists-in-exile, leading to his incorporation of personal symbols, gleaned from internal subconscious sources, in his work.

This painting is one in a series begun in 1955 in which the French words for "I love you," are incorporated into the composition of each painting. As a native of Aberdeen, Washington, Motherwell encountered East Asian calligraphy, popular in the Pacific Northwest, which inspires his use of handwritten words and the gestural

application of paint. The abstract image of a swan's wing makes reference to a mood-evocative poem by nineteenth-century French poet Stéphane Mallarmé. *Je t'aime No. VIII*, like the entire series, is characterized by its high-keyed color and fluid brush marks, revealing the range of emotion that is central to Motherwell's artistic style. The work is linked to a transitional period in the artist's life in which the disappointment of divorce is supplanted by great feelings of affection for his future wife, Helen Frankenthaler. Motherwell translates, with moving humanity, a personal experience into a compelling assertion of the universal need for love.

Andrew Wyeth (b. 1917)
Tenant Farmer, 1961
Tempera on Masonite
30½ × 40 in. (77.5 × 101.6 cm)
Gift of Mr. and Mrs. W. E. Phelps, 1964
DAM 1964-10

Considered America's premier Realist, Andrew Wyeth is best known for his watercolors and paintings of the landscape and people of Chadds Ford, Pennsylvania, and Cushing, Maine. The son of famous illustrator and painter N. C. Wyeth, Andrew achieved national recognition in 1940 when, at the age of twenty-three, he became the youngest member ever elected to the American Watercolor Society.

In the early 1940s, Wyeth began painting in egg tempera, a medium that enabled him to use his startlingly detailed technique to portray straightforward subject matter with a vaguely unsettling and enigmatic aura.

The inspiration for *Tenant Farmer* came from a specific experience: Walking home in the snow a few days before Christmas in Chadds Ford, Wyeth noticed a frozen deer strung from a willow tree next to a dilapidated

brick house. Beginning in January 1961, and over a span of four months, Wyeth painted the scene after completing a series of pencil and dry-brush studies of the house, woodpile, and deer. Composing the scene within a shallow spatial setting, Wyeth painted the sky as a still and airless backdrop against which the hanging animal, the bare branches of the tree, and the stark angles of the eighteenth-century brick house are prominent. The work appears cold and motionless, its movement implied only in the window curtain and dangling tree branches. An oppressive, heavy silence pervades the scene, lending a lonely and disquieting atmosphere to the work. For Wyeth—who recalled thinking of the young animal, which was at one time alive and running freely—the images of the deer and house in *Tenant Farmer* became symbols of death and decay.

Louise Nevelson (1899–1988)
Rain Forest Column XX, 1962–64
Wood painted black
94 × 13 in. (238.8 × 33 cm)
Purchased with funds provided in part by
the National Endowment for the Arts, and
other contributions, 1979
DAM 1979-58

One of the world's foremost sculptors, Louise Nevelson, born Leah Berliawsky, left Russia with her family in 1905 to settle in Rockland, Maine. She moved to New York City in 1920 with her husband, Charles Nevelson, and enrolled in art classes at the Art Students League. In 1931 Nevelson studied painting in Germany with Hans Hofmann. In the mid-1950s, Nevelson began to create powerful works, typically using boxes and found objects, which she arranged in complex, abstract assemblages within a constructed environment. The works reflected the influence of the Cubists and of Pre-Columbian art and architecture, which she had viewed on trips to Mexico and Guatemala. Nevelson referred to herself as an "architect of shadows." Her works, large in scale and uniform in color, focus on the play of light and shadow across the texture of their surfaces.

Nevelson's reputation soared in the 1960s when she exhibited a room-size installation at an International art exhibition in Venice, Italy. In this piece, a component of the work she exhibited, Nevelson combines rope-like strands and irregular geometric forms derived from the fragmented compositions of Cubism. Iron nails twist and bend in the wood. The work invites the viewer to peer into its interior spaces, behind its outer layers and around its corners—where one finds abstract references to a female form, a fragment of a Pre-Columbian ruin, and the darkness of the rain forest. In effect, Nevelson draws a

comparison between the essence of female energy and the nature of the rain forest: both are replete with hidden forms, secret recesses, and sensuous opulence.

Robert Indiana (b. 1928) ▶
Decade: Autoportrait 1964, 1971
Oil on canvas
24 × 24 in. (61 × 61 cm)
Purchased with funds provided by the
Friends of Art and the National Endowment
for the Arts, 1973
DAM 1973-10

Robert Indiana describes himself as a painter of signs. His work is linked to the Pop Art movement of the 1960s, which introduced images from popular culture into painting and sculpture to blur the boundaries between real life and fine art. Much of Indiana's work recalls words and numbers from highway signs, roadside diners, and pinball machines remembered from his Midwestern childhood and other periods of his life. These mundane words and figures, painted in bold, intense colors and executed in a flat, stencil-like style, take on the look of commercial advertising.

In 1971 Indiana painted two series of ten paintings that he called "autoportraits," a playful combination of *autobiography* and *self-portrait*. The paintings in the first series, all of which feature superimposed figures of a circle, star, decagon, and the numeral "1" on a square canvas, commemorate each year of the decade of the 1960s with personal references to the artist's life experiences. In this work, the "4" stands for 1964, and "71" represents 1971, the year in which the painting was completed. The phrase COENTIES SLIP refers to the low-rent, waterfront warehouse district at the southern tip of Manhattan where Indiana lived and maintained a studio in 1964. The IND refers to the artist's assumed last name—also the state where he was born. The brash, direct nature of this work is created through the starkly symmetrical surface arrangement of line, shape, and color.

Jim Dine (b. 1935)
Putney Winter Heart 8 (Skier), 1971–72
Oil on canvas with shoes, mitten, socks,
gloves, shirt, nail, rope, and tin foil collage
72 × 72 in. (182.9 × 182.9 cm)
F. V. du Pont Acquisition Fund, 2001
DAM 2001-4

Jim Dine's paintings are characterized by the incorporation of common everyday objects and symbols. Tools, robes, painters' palettes, gates, and hearts have dominated his work for nearly four decades. The heart, a universally recognizable symbol, is for Dine an emblem that evokes a host of personal associations. He has returned to this subject matter often, using it in what he describes as symbolic self-portraits, which embody his personal impressions and reminiscences of particular places or moments in time.

Dine created *Putney Winter Heart 8 (Skier)* shortly after he moved from New York City to a small farm in Putney, Vermont in 1971. After working outdoors during the summer, he built a small, insulated studio that autumn for working in cold weather. In this work—one of a series of large-scale paintings with the heart motif he created that winter—he dominates the canvas with a heart, painted with an expressive application of bold color and drips of paint. Dine added his handprint, along with everyday objects: a pair of shoes, socks, a shirt, rope, paint-encrusted workman's gloves, and a red woolen mitten, woven with the image of a skier. The work expresses the physical and emotional sensations Dine experienced in southern Vermont: the crispness of the cold air, the clarity of the blue skies, the joy of leisure activities, and the simple pleasure of working on the farm. *Putney Winter Heart 8 (Skier)* is an intensely personal work, an assemblage of colors, brushwork, and found objects that reflect the artist's feelings about his life.

Grace Hartigan (b. 1922)
Eleanor of Aquitaine, 1983
Oil on canvas
78½ × 72 in. (199.4 × 182.9 cm)
F. V. du Pont Acquisition Fund, 1995
DAM 1995-13

In the early 1980s Baltimore artist Grace Hartigan began a series of paintings entitled "Great Queens and Empresses." The series, adapted from a book of paper cut-out dolls by Tom Tierney, focuses on great historical female figures: Theodora, empress of Byzantium; Elizabeth I of England, Liliuokalani, queen of the Hawaiian Islands; Empress Josephine Bonaparte of France; and Eleanor of Aquitaine, queen of France and, later, England. To this group of five paintings, Hartigan added her contemporary translations of three paintings by Spanish painter Diego Velázquez, *Mariana of Austria*, *Lady with a Fan*, and *Infanta Margarita Teresa*. Although paper dolls are the inspiration for the series, Hartigan's figures, lacking the tabs used to attach paper clothing, are represented as more "real" than their paper counterparts.

In *Eleanor of Aquitaine*, Hartigan depicts two figures—one is featureless—to represent separately the introspective and public lives of Eleanor, who spent years imprisoned for plotting to overthrow her husband, Henry II of England. Hartigan employs her signature "drip veil" staining technique, in which thin washes of turpentine-diluted paint are applied to a coated canvas. She then manipulates the surface with a rag, house painter's mitt, and fan-shaped brushes, which creates the illusion of a veil that obscures time and memory.

Robert Colescott (b. 1925)
Big Bathers: Another Judgment, 1984
Acrylic on canvas
89 × 72 in. (226.1 × 182.9 cm)
F. V. du Pont Accessions Fund, 1986
DAM 1986-35

This painting alludes to the mythical story of the Judgment of Paris, the well-known contest in which Paris, a noble shepherd, must judge the beauty of three goddesses. The contest arose after Eris, the goddess of strife, threw down a golden apple inscribed with the words To the Fairest. Juno, Minerva, and Venus, all claiming the title, tried various bribes to win the golden apple from Paris. In the original myth, Venus triumphed, having offered Paris the lovely Helen of Troy, thus provoking the Trojan War.

This myth has been interpreted numerous times throughout the history of Western European art, yet Robert Colescott's contemporary version is one of the most amusing, titillating, provocative, and political. The boldly brushed and vividly colored painting, from Colescott's "Bather" series, begun in 1980, confronts racial and gender stereotypes. Comically exaggerated and grossly distorted goddesses of various racial and ethnic derivations show off their physical "wares" to a sleeping Paris—actually a self-portrait of the artist. Soundly asleep with the golden apple beside him, he seems unaware or disinterested in the consequences of his forthcoming decision. *Big Bathers: Another Judgment* reflects Colescott's preoccupation with sexism, and questions preconceived notions of beauty. He provokes the viewer to reflect on skin color, sex, and traditional canons of physical perfection in a racially diverse and culturally complex world.

Al Held (b. 1928)
Rome II, 1982
Acrylic on canvas
108 × 216 in. (274.3 × 548.6 cm)
F. V. du Pont Accessions Fund, 1987
DAM 1987-9

Al Held is considered one of the preeminent Hard-Edge Minimalist painters in the world. Born in Brooklyn, New York, in 1928, he attended the Art Students League from 1948 to 1949 and later studied in Paris at the Académie de la Grande Chaumière. Until 1959 he painted in a unique Abstract Expressionist style influenced by the gestural painting of Jackson Pollock and the nonrepresentational work of Piet Mondrian. Between 1960 and 1967, his work departed from the heavy textures of Abstract Expressionism toward a more tightly controlled, reduced aesthetic that focused on flat geometric planes and the minimization of color. In the early 1980s Held developed what he described as an "appetite for complexity" and began to explore, through the use of flat planes of bold color, curvilinear forms, and grids, the illusion of three-dimensional space on a flat surface.

Rome II is a complex and expansive labyrinth of color, space, and form. Space and depth appear to undulate as the viewer visually traverses the painting's boldly colored paths and moves among its elliptical forms. Held creates this visual phenomenon—the expansion and contraction of pictorial elements within the field—through the mathematically precise calculation and placement of line, shape, and color. On the canvas, Held worked through a process of taping and painting, making constant alterations. By eliminating any visible trace of the artistic process, Held is able to ensnare the viewer within an intricate picture space that seems to be in a state of continual flux.

◄ *Fold out*

Al Held
Rome II

Dale Chihuly (b. 1941)
White Sea Form, 1986
Blown glass
9 × 30 × 26 in. (22.9 × 76.2 × 66 cm)
E. Avery Draper Memorial and Acquisition
Fund, 1987
DAM 1987-179 a–e

Dale Chihuly is internationally recognized as one of the most distinctive and innovative artists working in blown glass. He challenges traditional expectations of the medium through his use of intense color, organic form, and expanded scale. He began to work in the medium in the mid-1960s when he experimented with blowing molten glass at the end of a steel pipe in his basement studio in Tacoma, Washington. He enrolled in Harvey Littleton's Glass Program at the University of Wisconsin–Madison, then the sculpture program at the Rhode Island School of Design, and later studied at the prestigious Venini Glass Factory on the island of Murano in Venice, Italy. Chihuly explored ancient glass-blowing techniques and conceived a collaborative approach later known as "Team Chihuly," the working basis of the Pilchuck Glass School founded by the artist in 1971 in Washington State.

Chihuly describes his art as revolving around a simple set of elements: fire, molten glass, human breath, spontaneity, centrifugal force, and gravity. This work is part of his "Sea Form" series, for which he explored new techniques and tools, such as the ribbed mold, to support increasingly large glass forms. The mold produced undulating patterns in the glass that are reminiscent of the raised ribbed patterns of seashells. Organic, translucent shapes with subtly applied tracery and a webbed delicacy of form, enhanced by the fluidity of the colored lip wrap, make this one of Chihuly's most elegant statements in glass.

James Browning Wyeth (b. 1946)
Mischief Night, 1986
Mixed media on paper
22½ × 31 in. (57.2 × 78.7 cm)
F. V. du Pont Acquisition Fund, 1991
DAM 1991-127

A superlative American Realist whose work evolved out of the Brandywine River tradition, James Browning Wyeth is the youngest child of Andrew and Betsy James Wyeth and a grandson of the illustrator N. C. Wyeth. Born in Chadds Ford, Pennsylvania, and taught at home by a tutor after the age of six, Wyeth was exposed to the world of fine art by his father and grandfather, and through his formal art training with his aunt, Carolyn Wyeth. James Wyeth began to study with his father in 1960, and moved to New York City in 1963, where he found his own artistic voice. He is known for his portraits, genre paintings of animals and farm life, landscapes of the Brandywine River region, seascapes of the coast of Maine, and strange, narrative paintings that are unique for their humorously macabre content.

Mischief Night of 1986 falls within the last category. A wicker basket holding a walking cane and pumpkin is set against the backdrop of an ominously dark night sky. The dead vine of the pumpkin has an anthropomorphic quality, resembling the elongated skeletal arms of a mysterious presence whose ghostly shadow emanates from beneath the wheeled cart. This scene of eerie transformation possibly refers to the unworldly possibilities unleashed on Halloween. The narrative in *Mischief Night* is at once humorous and terrifying and—as Michael Preble, in his writings on James Wyeth, has aptly pointed out—resides somewhere between Washington Irving's classic tale *The Legend of Sleepy Hollow* and an Alfred Hitchcock movie thriller.

Deborah Butterfield (b. 1949)
Riot, 1990
Steel
81½ × 120 × 34 in. (207 × 304.8 × 86.4 cm)
F. V. du Pont Acquisition Fund, 1991
DAM 1991-126

Born in 1949 in San Diego, California, and educated at the University of California, Davis, Butterfield has pursued the equine form as the subject of her art since the early 1970s. Her sculptures of standing and reclining horses reveal the artist's appreciation and respect for the strength, beauty, and spirituality of her subject. Describing her images as "metaphorical substitutes" for herself, Butterfield seeks to create a parallel between horse and human.

Butterfield first sculpted horses in 1973, using plaster on a steel armature.

After moving to Bozeman, Montana in 1976, she began working with materials she discovered in the mountain terrain, such as mud and sticks and old wooden fencing salvaged from the local pastures. With these materials, her work began to take an abstract form—more open and dematerialized—through which she captures the essence of the subject. In the 1990s, Butterfield became interested in the constructivist vocabulary of found materials, such as scrap metal, steel, and iron.

Riot, a 1990 work, is constructed entirely of steel beams and metal signage from a demolished movie theater. A prominently visible R and a T from the theater sign form the hindquarters and shoulders of the animal. Desiring to expose the spirit of the horse, Butterfield guides the viewer's eye around and through the equine's open, yet imposing form.

Elizabeth Talford Scott (b. 1916)
Grandfather's Cabin/Noah's Ark, 1993–1996
Hand-sewn fabric quilt with mixed media
70 × 50 in. (177.8 × 127 cm)
Gift of the Alberta du Pont Bonsal Foundation, 2000
DAM 2000-16

Elizabeth Talford Scott was born in 1916 near Chester, South Carolina, on the land her ancestors worked as slaves and later, sharecroppers. She learned to piece and sew fabric into quilts at the age of nine from her parents for purposes of barter, warmth, and decoration. In the 1940s she settled in Baltimore where she continued to quilt in moments stolen from a life devoted to raising her children and working as a domestic caterer and caretaker. After retiring in the 1970s, Scott focused her full attention on quilt making, expanding her artistic vocabulary to include designs derived from African and African American sources, and including unusual materials, such as sequins, beads, buttons, shells, bones, plastic netting, and rocks. Over the years, Scott has explored new cultural and aesthetic directions, transforming the concept of quilt making from a domestic craft into a high-art form.

In her work Scott often draws upon her impressions and memories of childhood as well as her religious and spiritual beliefs. *Grandfather's Cabin/Noah's Ark* combines the memory of her grandfather's house and garden with the biblical tale of Noah's Ark. Fantastic animals, insects, and flowers dot the surface of the quilt, along with stars—a reference to the African slave tradition of using the constellations to map the freedom trail along the underground railroad. For Scott the motifs, objects, and materials she utilizes represent instruments of personal and cultural healing; she often refers to her completed quilts as prayers.

George Segal (1924–2000)
Swan Motel, 1999
Plaster, wood painted black, Lite-Brite pegs,
light bulbs, and sockets
96 × 96 × 27 in. (243.8 × 243.8 × 68.6 cm)
F. V. du Pont Acquisition Fund, 2000
DAM 2000-17 a–c

In 1958 George Segal gave up full-time farming and converted the chicken coops on his New Jersey farm into studios. Influenced by audience-participation events known as "happenings" in the late 1950s and 1960s, Segal began to experiment with sculptures of human figures. He used plaster, burlap, and chicken wire, and placed the figures with everyday objects. Later he began casting plaster sculptures from live models, capturing the essential traits without specific detail. Segal often emphasized the solitary individual, or a sense of isolation among several people, through depictions of ordinary people performing mundane routines.

Swan Motel is the final work created by the late artist. The nightscape, a large-scale environment, focuses on the commercial culture of the American roadside. Set against a black background, with the suggestion of automobile lights, distant highway lights, and neon signs, a solitary, life-size female walks along a strip of highway into the viewer's space. The figure, dressed in jacket, pants, and boots, and carrying a purse, is a plaster cast of the artist's daughter Rena. A sign behind her, RENA'S DELI, provides the clue to her identity. While the commonplace nature of this narrative invokes a sense of familiarity, the commentary—on the dissonances among the human, mechanical, and commercial aspects of the contemporary world—is disquieting. Although Segal is tied to artists of the Pop Art movement, such as Andy Warhol, Roy Lichtenstein, and Tom Wesselman, his tableaux of everyday life can also be viewed as part of the American Scene tradition, which allies him with John Sloan and the Eight, and Edward Hopper.

SELECTED BIBLIOGRAPHY

Cohen, Marilyn, *Reginald Marsh's New York: Paintings, Drawings, Prints, and Photographs*. New York: Whitney Museum of American Art in association with Dover Publications, 1983

Elzea, Rowland and Iris Snyder, *American Illustration: The Collection of the Delaware Art Museum*. Wilmington, DE: Delaware Art Museum, 1991

Elzea, Rowland and Elizabeth H. Hawkes, *John Sloan: Spectator of Life*, exhibition catalog. Wilmington, DE: Delaware Art Museum, 1988

Elzea, Rowland and Elizabeth H. Hawkes, *A Small School of Art: The Students of Howard Pyle*. Wilmington, DE: Delaware Art Museum, 1980

Goodman, Cynthia, *Hans Hofmann*. New York: Whitney Museum of American Art; Munich: in association with Prestel-Verlag, 1990

Hawkes, Elizabeth H., *American Painting and Sculpture, Delaware Art Museum*. Wilmington, DE: Delaware Art Museum, 1975

Hawkes, Elizabeth H., *John Sloan's Illustrations in Magazines and Books*. Wilmington, DE: Delaware Art Museum, 1993

Howard Pyle: Diversity in Depth, exhibition catalog. Wilmington, DE: Delaware Art Museum, 1973

Howard Pyle: The Artist, The Legacy, exhibition catalog. Wilmington, DE: Delaware Art Museum, 1987

Hunter, Sam, *George Segal: Nightscapes*, exhibition catalog. Philadelphia, PA: Locks Gallery, 2000

Kraft, James and Helen Farr Sloan, *John Sloan in Santa Fe*, exhibition catalog. Washington, D.C.: Smithsonian Institution Traveling Exhibition Service, 1981

Levin, Gail, *Edward Hopper, A Catalogue Raisonné*. New York: Whitney Museum of American Art in association with W. W. Norton, 1995

Pitz, Henry C., *Howard Pyle—Writer, Illustrator, Founder of the Brandywine School*. New York: C. N. Potter, 1975

Wondrous Strange: The Wyeth Tradition: Howard Pyle, N. C. Wyeth, Andrew Wyeth, James Wyeth, exhibition catalog. Boston: Little, Brown and Co., 1998

INDEX

Page numbers in *italics* refer
to images